Naturally
Brilliant Colour

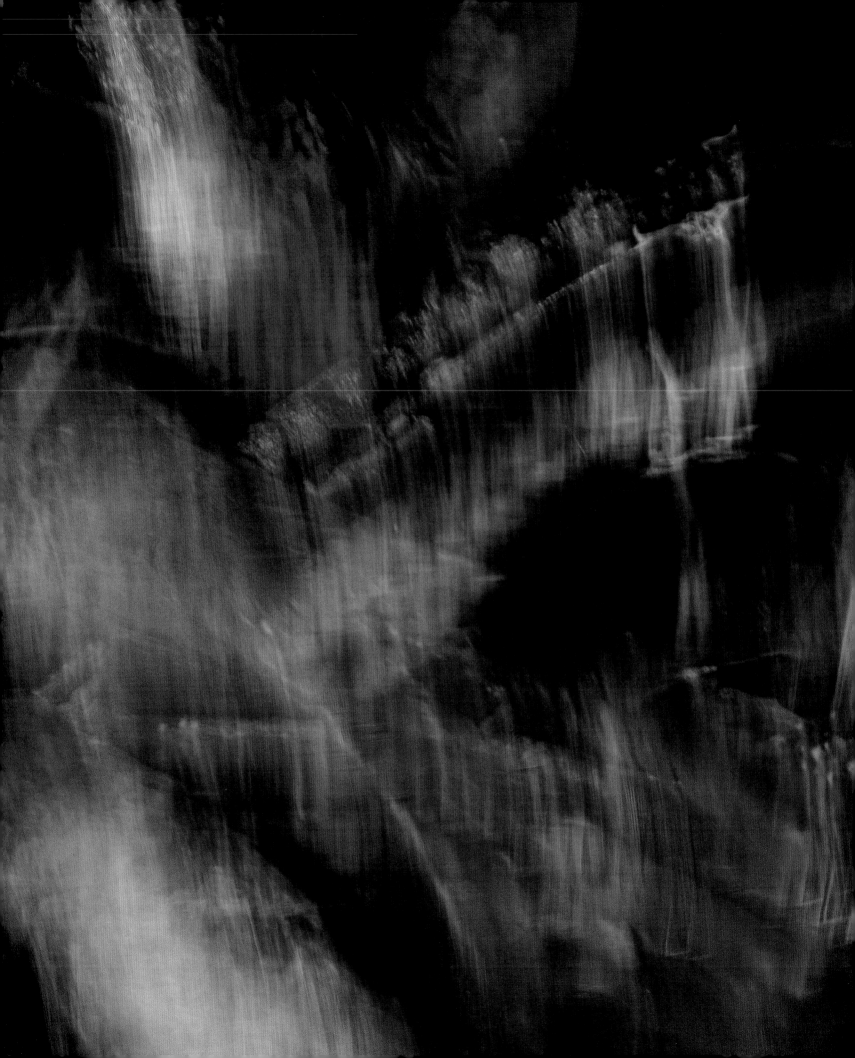

Naturally Brilliant Colour

Andrew Parker

Kew Publishing
Royal Botanic Gardens, Kew

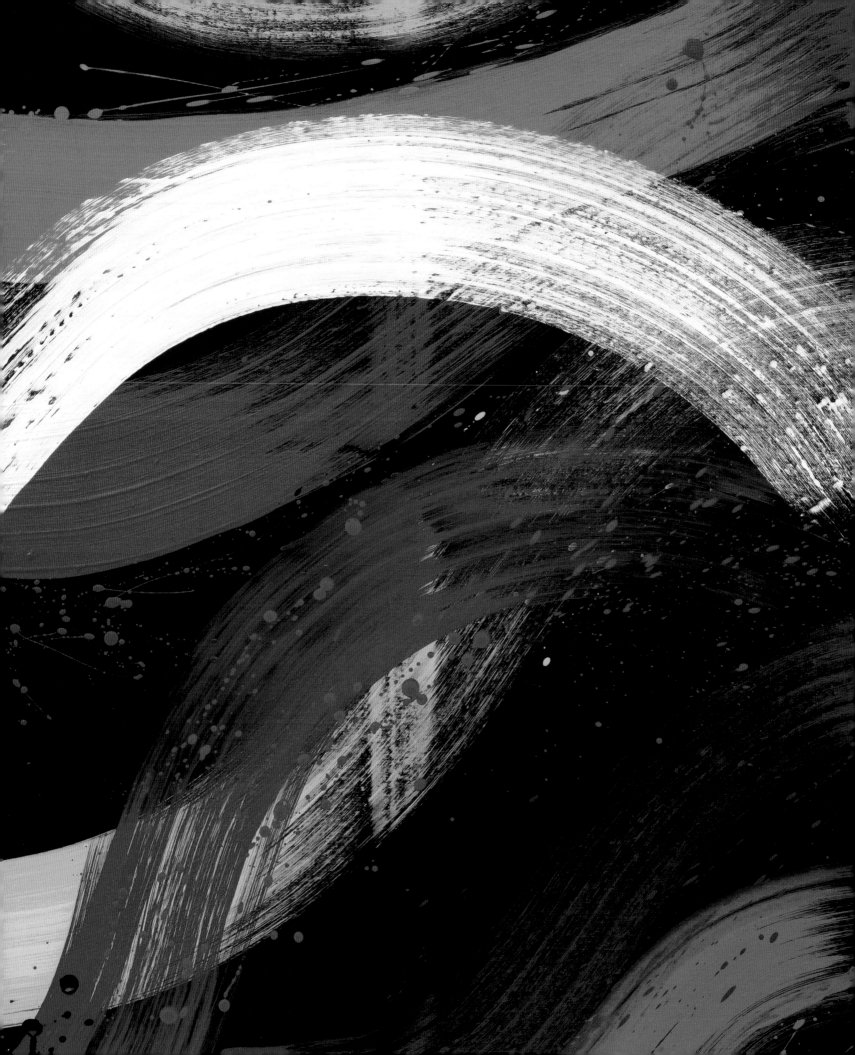

To my sons, Lorenzo and Leonardo

Pure Structural Colour is the most vivid colour I have seen, reminiscent of the jewel-like shades that until now could only occur in nature. This is what makes Pure Structural Colour so exciting, bringing something usually glimpsed on a small scale, like the hues found in hummingbirds, tropical fish and beetles for example, into a world of huge possibility. It is very versatile in scale, with applications ranging from large surfaces to tiny flakes.

In person, Pure Structural Colour is mesmerising. Really, the impact is such that it's hard to conceive of Pure Structural Colour as only containing transparent materials.

Marc Newson, designer

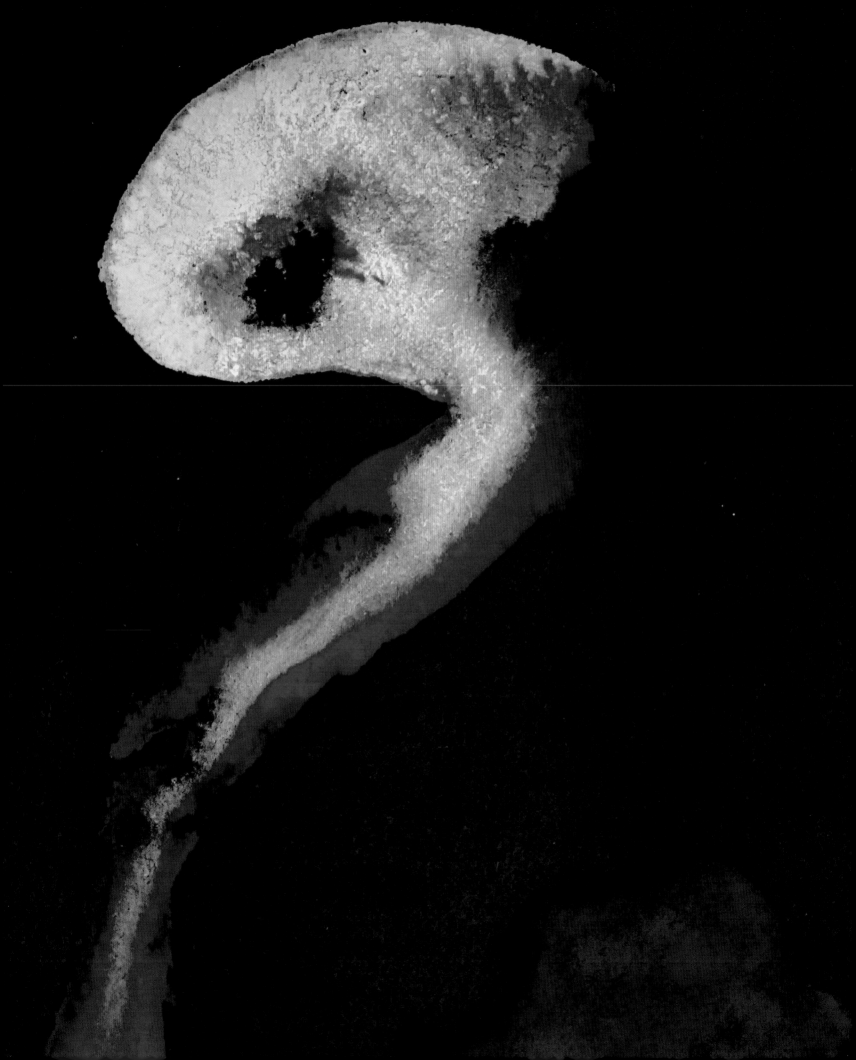

Contents

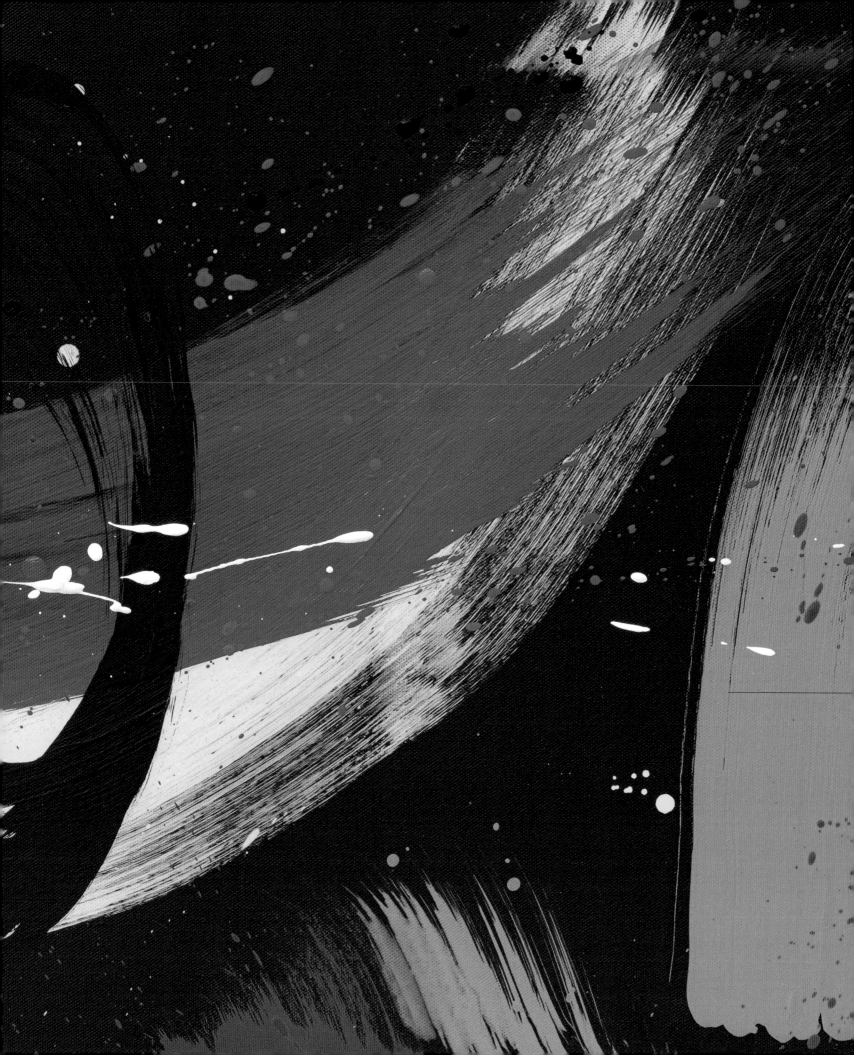

Foreword

This book is based on an unprecedented exhibition held at Kew Gardens, displaying for the first time the brightest colours ever to have been created, using innovative technology – Pure Structural Colour – developed by scientists, taking inspiration from nature.

Replicating microscopic structures and mechanisms, found in the natural world on the surfaces of plants and animals to reflect and refract sunlight, Pure Structural Colour produces colours artificially in a specific way, in their most vivid and naturally brilliant form.

The pages that follow take the reader through Andrew Parker's journey, beginning as a fascination with the most intense colours found in nature, from blue-green tinges of iridescent plant fruits such as *Pollia*, to the wings of tropical butterflies and hummingbirds, in rainforests, coral reefs, ocean depths, and leading to the development and creation of Pure Structural Colour.

The scene is set by examining the first eye and the origins of vision and colour. This is a wonderful example of how remarkable evolution is, as a mechanism for experimentation and then selection of the most desirable forms to ensure survival.

The types of colour in nature are explored, as is the quest to reproduce colour in natural history illustration, including the world's first experimental botanical artwork to use Pure Structural Colour, by artist Coral G. Guest.

The rich beauty of colour in all forms and shapes is used by plants and animals to survive and thrive. Pure Structural Colour is a product of bioinspiration, an innovation taken from nature that has inspired a technology. This, and similar innovations can potentially help us to live more responsibly, reducing our environmental footprint, and ultimately protecting biodiversity and life on earth. Never has this been more urgently needed.

If I were asked to distil the Royal Botanic Gardens, Kew into just two words I would choose 'science and beauty'. It is for this reason that I am so delighted we are hosting this world-first exhibition on Pure Structural Colour as it is the perfect amalgam of these two concepts.

Richard Deverell
Director (CEO)
Royal Botanic Gardens, Kew

1
Background

This 'art and science' project has been a long time in the making. Through my fascination with colour, I began my career as an artist and a scientist. After ten years in Australia, I grew so distracted by the brightest colours I had ever seen that I became compelled to reproduce them. These are the colours found not just in the rainforests and coral reefs of Queensland, but also in the deep sea, where background light is so limiting that only colour that is one hundred per cent reflective will function. This is a type of colour known as 'structural colour,' which ironically is produced by transparent materials that are minutely and intricately sculpted to refract and reflect light.

Since 1990, I taught the potential merits of this colour in my university art classes, while researching the examples found in nature in my science lab. Some peculiar marine worms and diminutive crustaceans offered clues towards the type of microscopic structures responsible for this optical phenomenon. Parts of animals and plants better known for this type of colouration, from tropical butterflies and beetles to marine algae and birds of paradise, were then put into the electron microscope. Although the microstructures in each case were different, it emerged that the general principles of reflecting light were the same. Those same principles – a winning formula to make oneself ultra-attractive – had evolved many times. But was there a way to make this colour in the lab?

To begin, I cheated. I cultured the living cells of a *Morpho* butterfly chrysalis – the cells that produce the wing scales (there are about 100,000 scales on a butterfly's wing) – and, after much experimentation, waited for those cells to make structural coloured scales. Perfect, electric blue scales emerged in my lab, but the cells' components had been sacrificed as part of making the microscopic structures. In other words, the cells could not continue making structural coloured scales. There was no potential artist's paint here.

My first manufacturing success was equally short-lived. I had copied one of the natural microstructures, with dimensions reaching the nanoscale (a thousandth of a hair's width), too closely. It is possible for animals and plants to make these efficiently because their 'factories'

[below] The antenna of the ostracod (Crustacea) *Azygocypridina*, showing structural colour.

[right] The marine worm (Polychaeta) *Pherusa*, displaying structural colour.

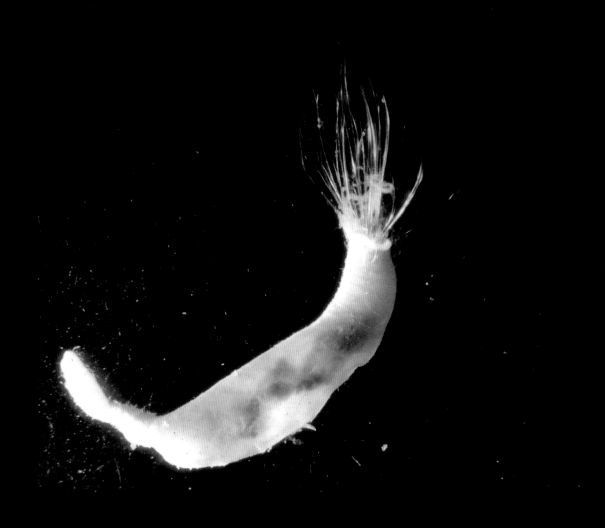

are cells, fitted out with nanosized 'machines.' But in human engineering, great effort, time and cost was required just to carve out a dot-size of this colour in highly technical 'clean room' laboratories.

Eventually, 25 years into this journey, the penny dropped. I found a way to reproduce this colour using commonplace machines and everyday factories. The same deep, velvety yet intense colour effect as found on a *Morpho* butterfly's wing, and all those weird and wonderful creatures I had once marvelled over, sprung from workshops in a complete spectrum of hues. Since the hue can appear the same from many directions, thus making an object uniformly coloured, this could be considered the world's brightest colouration, and became known as Pure Structural Colour.

I returned to my original artworks, which had been inspired by evolutionary events and the developmental processes of bodies, and replaced the standard, pigmented paint with my new type of colour. The patterns immediately leapt from the canvases in a new lease of life.

Those original artworks are reproduced in this book. The nature-inspired patterns are there to see, along with a hint of the intensity and luxury of the hues, albeit the true visual effect can only be gained from observing the canvases themselves. Then, one can observe the type of colour that the eye may have evolved to most enjoy.

Before presenting the Pure Structural Colour artworks, this book will set the scene by examining the evolutionary origins of vision and colour, and place this type of colour in context in nature and in natural history illustrations and art. The story begins with the evolution of the first eye, without which, colour would not exist.

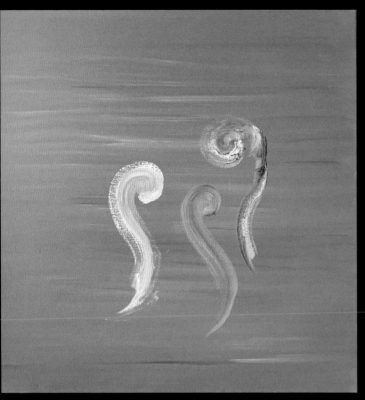

Development of Bodies, I (Yellow)
and *II (Red)*, oil on canvas,
Andrew Parker, 1990.

Two early 'swirl' and 'colour
explosion' paintings, set during
the Big Bang of evolution, around
520 million years ago. The swirls
represent the early evolution of new
species while not yet fully adapted
to the presence of vision. They
attempt to capture the spontaneity
of matter shaping itself partly
under the influence of energy
('self-assembly'), including all the
tensions and resolve along the way.
It is interesting that, in some cases,
paint itself can undergo similar
'self-assembly.' The background
in these paintings represents an
environment where vision has just
emerged but the starting gun for
adapted colour has only just fired.

Developmental Flow I, watercolour on paper, Andrew Parker, 1990.

The position of paint application is determined by the artist's hand, but the pigments bleed across the paper according to fluid dynamics (and a further little help from the artist). This mirrors the flow of pigment over a developing flower petal or butterfly wing, where genes govern the production of the pigment but colour patterns self-assemble as those pigments diffuse across the surface, such as observed in chromatography.

Developmental Flow II [above]
and *III* [right], watercolour on paper,
Andrew Parker, 2020.

More recently, the painting style
used in *Developmental Flow I*
was further developed to capture
the depth of luminosity and,
ultimately, the sense of the energy
experienced in Pure Structural
Colour. In Pure Structural Colour,
the high energy in the reflected
light generates the intensity of
hue; in *Developmental Flow II*, *III*,
IV and *V* (where this is not possible
because pigments are used),
high energy is represented in the
dynamism of the flow patterns of
the pigment, generated by diffusion
and interference.

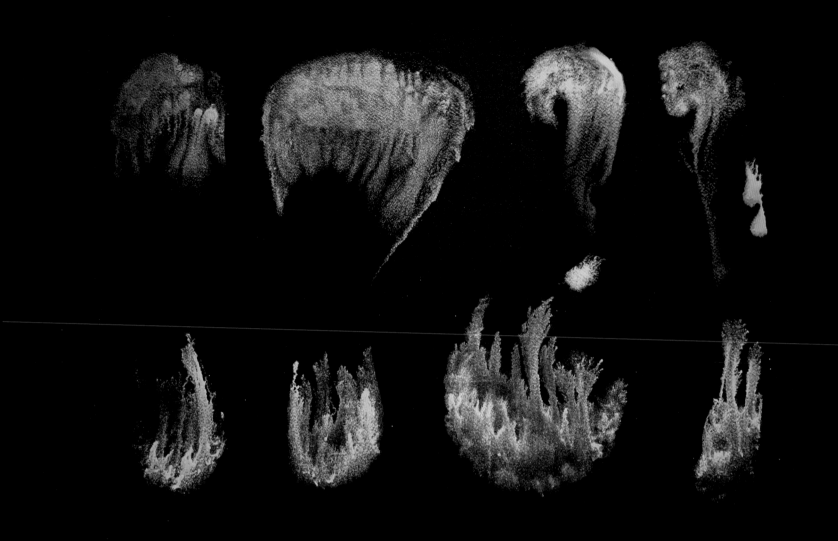

Developmental Flow IV [above]
and *Developmental Flow V* [right],
watercolour on paper, Andrew
Parker, 2020.

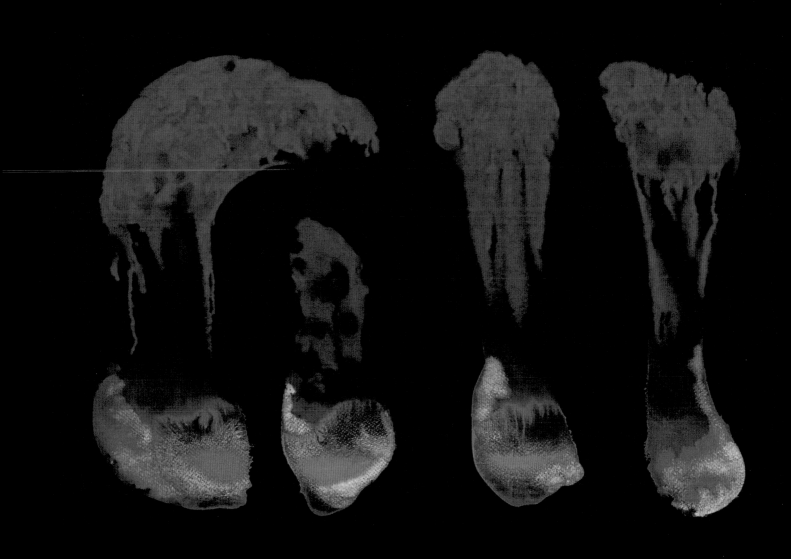

2
The evolution of vision and the beginning of colour

In the four-panel painting *Composition of Sunlight* (page 20), sunlight is unravelled into its seven colours. Mixed together, the human eye observes these coloured rays as 'white.' The suns rays, however, are not coloured – they have different wavelengths, which the visual system converts to colours.

The four-panelled painting *The Unrivalled Advent of Vision* (pages 22 and 23) represents a period of life in the distant past, including the era when vision suddenly evolved. Here, the white wave that cuts across the paper, travelling through geological time, represents the ever-present sunlight that has always existed on Earth. The organic shapes represent animals which lived in different epochs in time. The silver-white oval shape represents the evolution of a lens within an image-forming eye, and *vision*, ensuing that the different wavelengths of light would appear as colours. The first image-forming eye triggered chaos in the evolution of animals.

To further explain this painting, the first panel covers the time when life began in the sea, around 3,900 million years ago. It remained single-celled for 3,000 million years. With reference to plants, the first green plant cell appeared around 2,700 million years ago.

The second panel represents the period when the first animals with bodies containing multiple cells appeared, around 1,000 million years ago. It is significant that these bodies were all soft, like worms and jellyfish – it is economical, in terms of energy, to have and maintain a soft body.

The third panel hosts a time around 520 million years ago, when one group of animals – trilobites – evolved image-forming eyes. Trilobites also evolved hard skeletons and swimming and predatory capabilities. The other animals became exposed as defenceless chunks of protein. Vision and colour were born and were introduced to life on Earth in a relatively sudden blow. Colour is 'virtual reality' in that it is a construct of the mind – it exists only in the brains of animals with eyes.

The final panel in *The Unrivalled Advent of Vision* represents the evolutionary reaction to the presence of the fleet-footed trilobites and their eyes. Other animal species rapidly evolved hard, protective body parts and changes to their behaviour (such as agile swimming), to survive the new threat posed by vision. Some species even evolved eyes and predatory instincts themselves. All species appeared in colour for the first time and so evolutionary pressures began fine-tuning their body hues. This event became known as the Cambrian explosion, or the Big Bang of animal evolution. Indeed, it mainly concerned animals; the first land plants evolved later at around 470 million years ago, while flowers appeared around 160 million years ago, with colour palettes to attract the eyes of the fast-diversifying flying insects, in particular.

The artwork *A Revolution Waiting to Happen* (page 25) is an attempt to demonstrate the titanic behavioural advantage provided by eyes. Before 520 million years ago, animals possessed only simple light sensors, which could detect the brightness and direction

An approximately 520 million-year-old trilobite (*Cambropallas* species), bearing some of the first eyes on Earth.

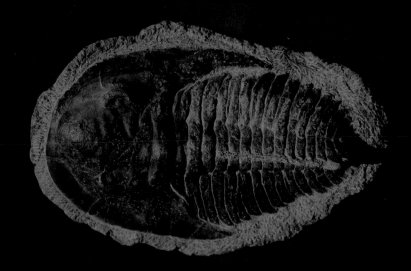

of sunlight. But the best 'image' these light sensors could muster was merely a blur. The evolution of a lens changed all that. Suddenly, sharp images of the surrounding world were formed on the light sensors, which collectively became a retina. Like never before, animals with eyes could now pinpoint the location of a nearby species and instantly assess its defensive capabilities. The energy-efficient, soft bodies of sluggish animals would no longer suffice. Evolution would go into overdrive. Life would change forever.

The animal seen in *A Revolution Waiting to Happen* is *Pikaia*. *Pikaia* was one of the earliest chordates, (member of the phylum Chordata), the group to which we belong. It also possessed eyes. The eyes of *Pikaia*, and our other ancestors which passed through later periods in geological time, evolved precise adaptations to their environments, which changed through time. These adaptations could not easily de-evolve, and so we carry them in our eyes and brains today. They explain why we are as we are. They explain our alertness to the colour red and why blue causes us to awaken, and ultimately our evolution of consciousness. But the original adaptation provided by eyes was to form images and to add colour to a colourless world.

The making of the experimental work *A Revolution Waiting to Happen* began with an acrylic painting of a Cambrian scene, including *Pikaia*. A Fresnel lens was placed at some distance from the painting, causing the light rays emanating from the painting to cross beyond their focal point and diverge, so that the image appears as a blur. A spherical (convex) lens made from transparent calcite – the material of the trilobite lenses, in those first eyes – was further placed in front of the Fresnel lens, causing the diverging light rays to be refocused back towards our eyes, and a sharp image to form on our retina.

When we view the painting through the Fresnel lens only – as a blur – we glimpse the best type of resolution detected by animals before eyes evolved. When we view the painting through the Fresnel lens *and* the spherical lens, we experience a glimpse of what those very first eyes would have seen. We become armed with lucid information on the animals that lie ahead, and their visual appearance offers further information on their defences and how they might fare in a pursuit. All very useful for a predator.

The first image in this chapter is reserved for the main protagonist in this narrative, an approximately 520 million-year-old trilobite (*Cambropallas* species), which bore some of the first eyes on Earth. Its large pair of eyes can be seen as curved ridges in the head.

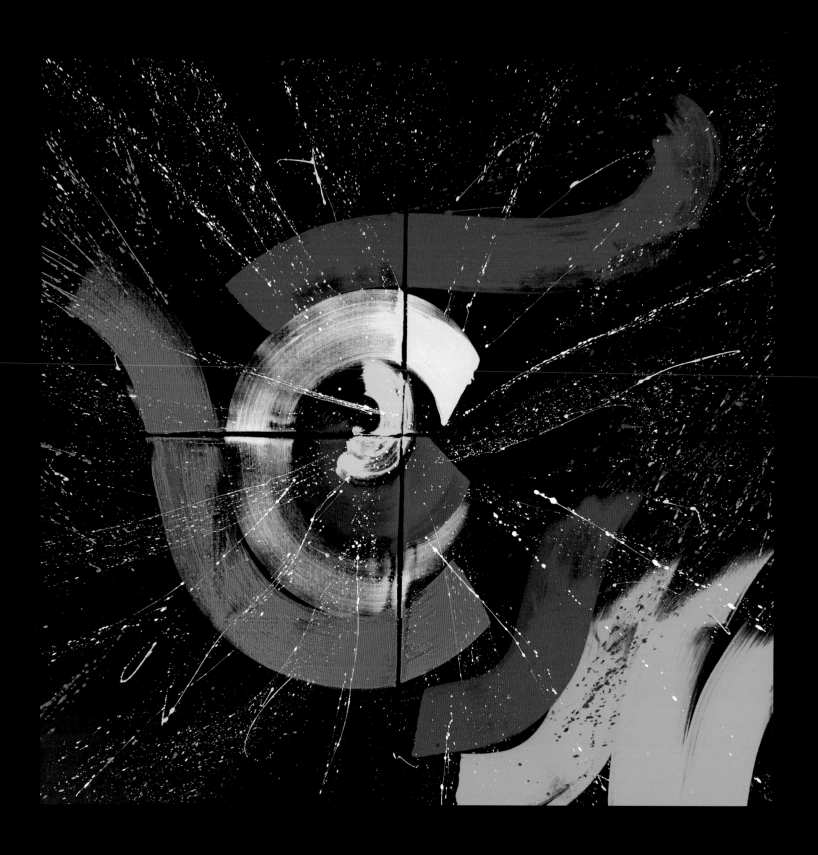

Composition of Sunlight, acrylic on
canvas, Andrew Parker, 2020.

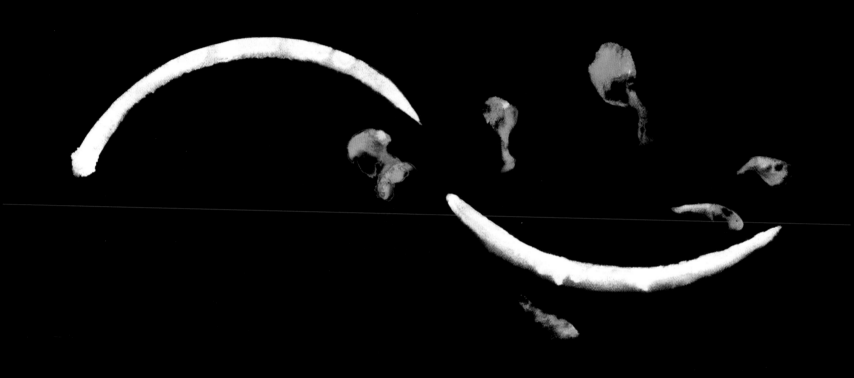

The Unrivalled Advent of Vision,
gouache on paper, Andrew Parker, 2020.

A Revolution Waiting to Happen,
Andrew Parker, 2019. Acrylic
Fresnel lens and calcite spherical
lens. Painting of *Pikaia* by Mary
McMenamin, 1995, acrylic on board.

This artwork shows a painting
of the Cambrian animal *Pikaia*,
which appears unfocused in the
background, viewed through a
Fresnel lens. A refocused portion
of the painting can be seen in the
central region, where the unfocused
painting is further viewed through a
spherical lens, which represents the
lens of a trilobite's eye. This artwork
demonstrates the life-changing
advantage conferred to those
animals with the first eyes.

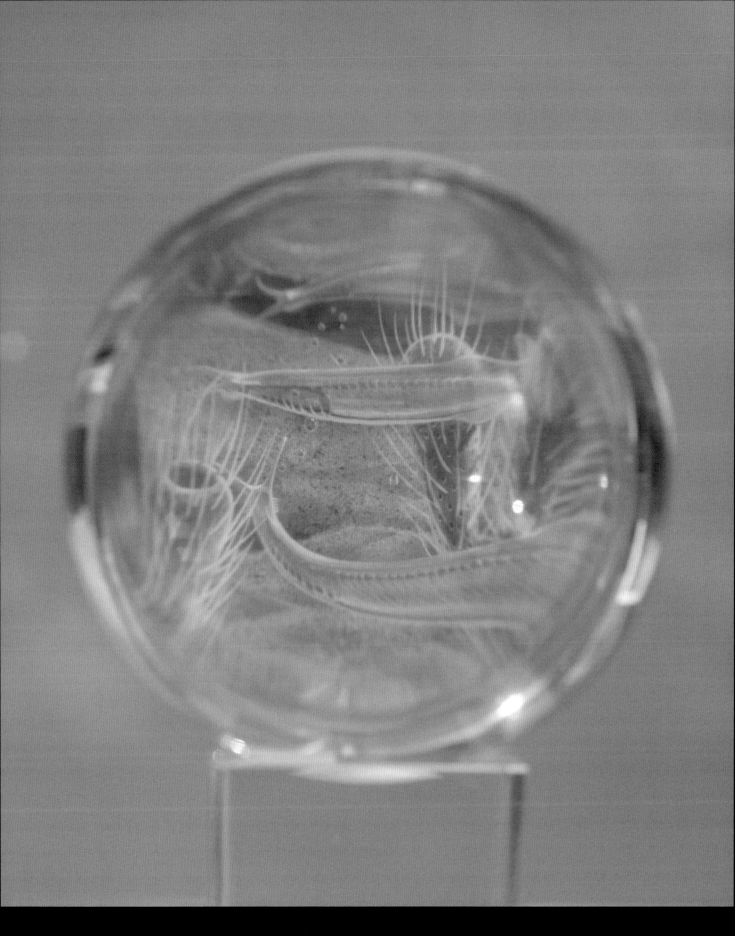

3
The types of colour in nature

Light exists in the form of electromagnetic rays, which each have a characteristic wavelength, or frequency. Sunlight is made up of rays with a mixture of wavelengths. Our eyes detect these, and our brains convert each wavelength to a different colour. Consider the way that prisms or raindrops split 'white' sunlight into its rays of different wavelengths, and how we see these as a spectrum of hues or a rainbow. In around 1665, Isaac Newton first identified these colours as red, orange, yellow, green, blue, indigo and violet, and arranged them clockwise in his famous 'colour wheel.'

So how do things appear different colours when lit by white sunlight? Within the surfaces of plants and animals, there are three different, microscopic 'machines' which involve atoms, molecules or even tiny structures. These machines back reflect rays of only one (or some) of the sun's wavelengths. There is a further machine that produces its own light rays. Animals with eyes detect the rays that are reflected or emitted, and experience them as colours.

Photographs of animals and plants containing the four different machines are presented in this chapter. Also presented are photographs of artworks made using each of the machines, where dots represent the bodies of animals or plants, and the patterns mirror their natural distributions within a community. Think of the patterns of oak trees in woodland or lichens on exposed rock. The eye has evolved to anticipate and appreciate such patterns. However, all images in this book have been reproduced using inks that contain pigments as their colour machine. Therefore, the real effect of each colour machine, except for that of pigments, cannot be observed here. The real visual effect can only be experienced by viewing the plants and animals, and artworks themselves.

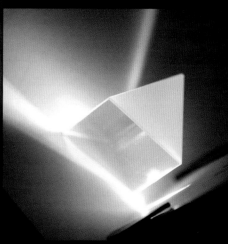

[right and above] A prism splitting white light into its component wavelengths, which appear as different colours to our eyes.

[far right] A cassowary, displaying two types of colour machines – the blues are a form of structural colour, while pigments cause the other colours (including black; black pigments absorb all wavelengths in white light).

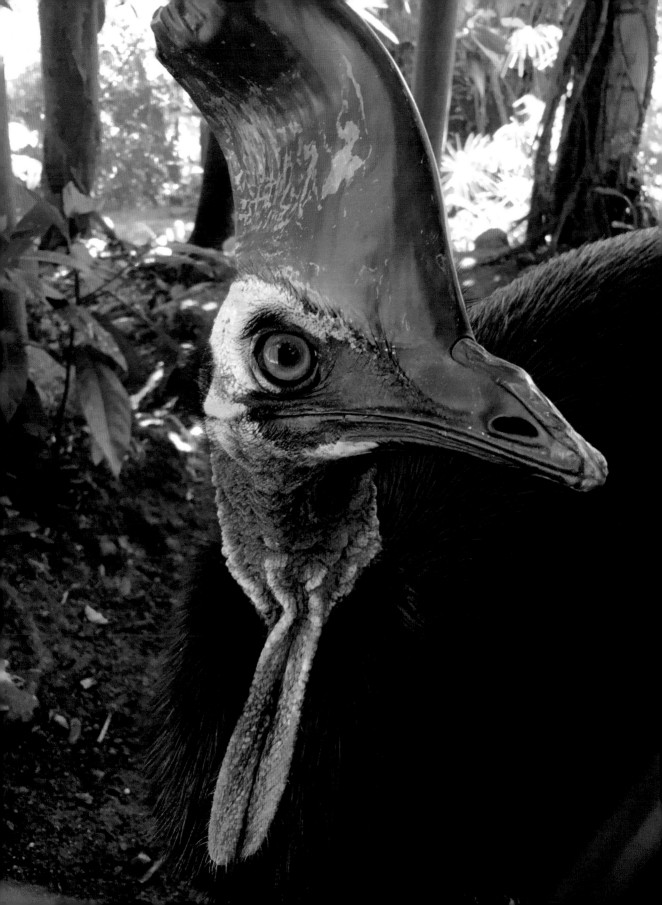

Colour machine I: pigments

Pigments, like most of those in paints and dyes, are molecules that absorb some of the sun's rays and backscatter others. A flower backscattering rays of 585 nanometres wavelength will appear yellow to us; rays of 490 nanometres wavelength will appear cyan. The artwork *Pigmented Bodies* (page 31) backscatters these wavelengths and absorbs most others from within the

somewhat misshapen ('organic') dots. The flamingo and flower photographs on these pages both contain pigments in their feathers and petals that backscatter rays of slightly different wavelengths, appearing different shades of red to our eyes. Pigments represent the commonest form of colour in nature. Most artworks, and paints, also rely on pigments to produce their colours.

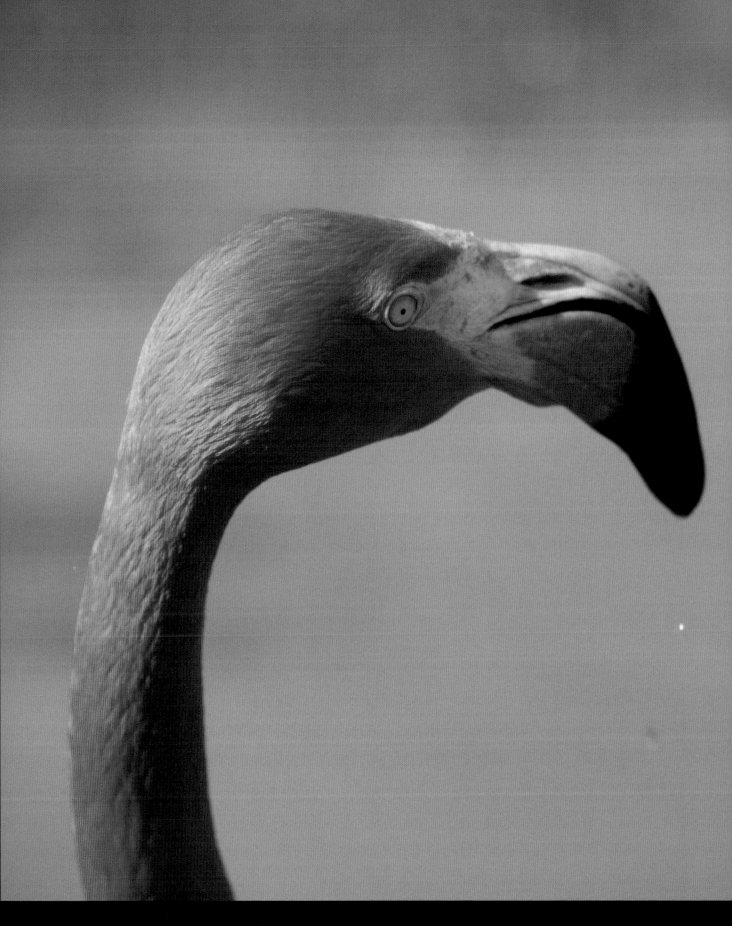

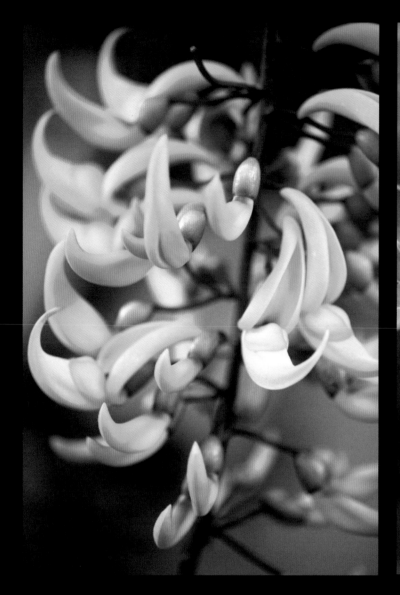

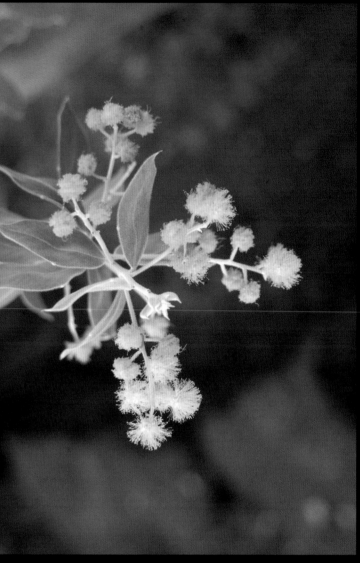

A jade vine, an endangered plant with unique pigments.

Acacia, from Australia, showing flowers that contain an unusual yellow pigment.

[right] *Pigmented Bodies*, acrylic on canvas, Andrew Parker, 2019.

In this and the following 'dot' paintings, the light energy within the paint colourant increases the perceived tension between individual dots, seemingly forcing them apart. The higher the luminosity, the greater the tension; pigments exhibit the weakest effect here.

Fluorescence occurs when the atoms of some molecules absorb ultraviolet rays, which we do not see, and re-emit them as rays which we do see (as orange and red, for instance). Sometimes, fluorescence in nature is incidental, in that it has no visual function, but sometimes it can serve a purpose in animals and plants. For example, fluorescent patterns on flowers can direct bees towards the nectar, and the fluorescent feathers of parrots can enhance the conspicuousness of courtship markings.

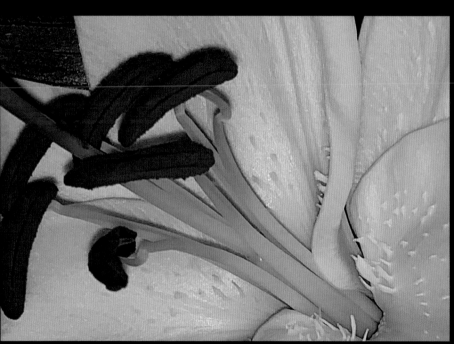

[left] Lily flower, photographed under white light [above] and under ultraviolet light only [below], showing fluorescent colours.

[right] *Fluorescent Bodies*, fluorescent acrylic on canvas, illuminated by ultraviolet light, Andrew Parker, 2019.

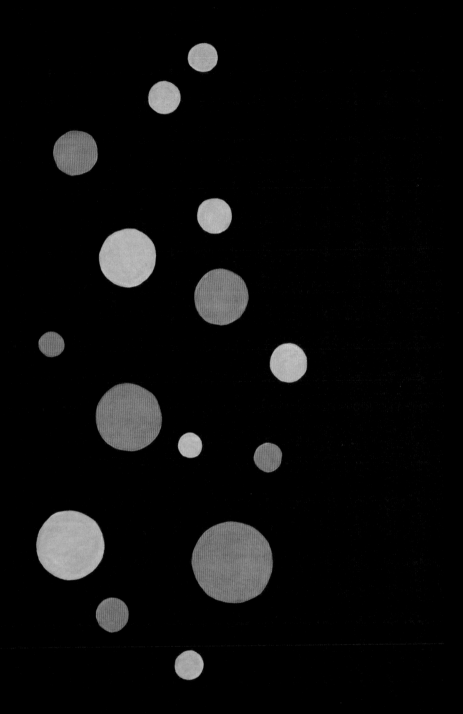

Colour machine III: bioluminescence

Some plants and animals make their own light as a result of a chemical reaction (like that in a glow stick), and so sunlight is not required. This type of colour is commonly seen in some animals or plants at night, or in caves or the deep sea. In the artwork *Bioluminescent Bodies*, electric lights replace the chemical reaction, but (rightly) light emanates from the artwork, rather than reflecting from it – it can be seen in the dark.

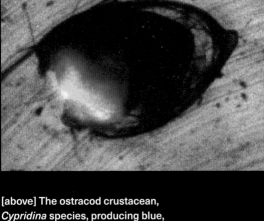

[above] The ostracod crustacean, *Cypridina* species, producing blue, bioluminescent light.

[right] *Bioluminescent Bodies*, reclaimed architectural coloured glass filters over white LED lights, Andrew Parker, 2019.

Colour machine IV: structural colour

Structural colour results from transparent materials, which are microscopically sculpted to selectively reflect and refract the sun's rays, like tiny prisms or holograms (such as the security holograms on banknotes). Structural colour can appear the brightest form of colour in nature (compare the pigmented print against the hologram on a banknote or credit card), and includes the 'metallic sheen' observed on some plants such as *Pollia* or *Margaritaria* fruits. Just as a large structure like an arm changes its shape through evolution, so too do the microscopic structures that cause structural colour, leading to different colours and different types of coloured effects (ranging from muted colours that appear the same from all directions, to flashes of bright and sparkly spectra).

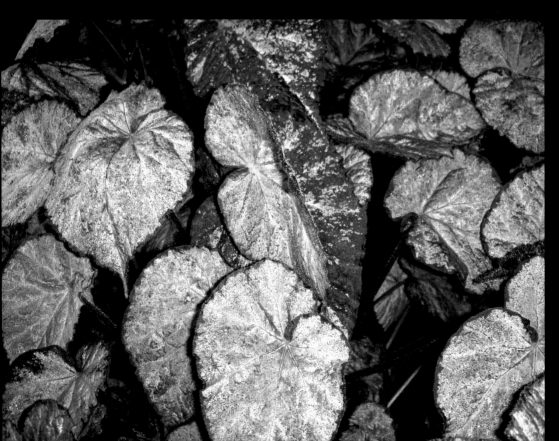

Begonia rex, where the silver and the blue colours result from the selected reflectance of sunlight by microscopic structures in the leaves. Silver results from the reflection of rays of all wavelengths in white light.

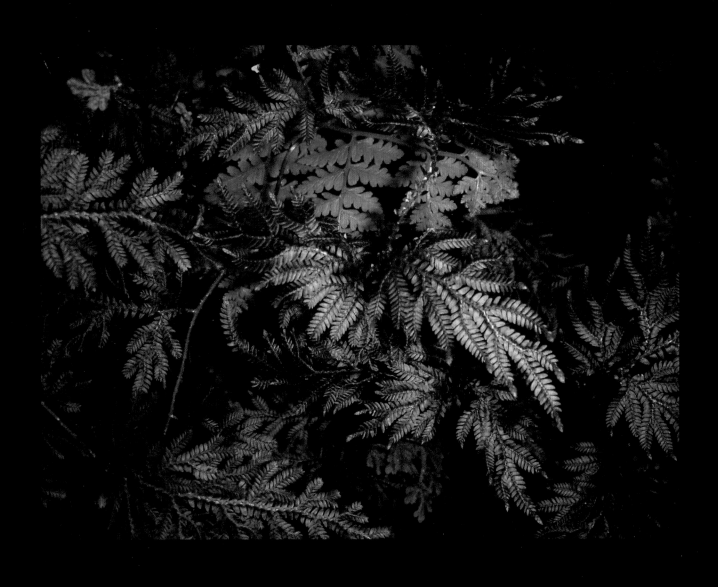

The fern *Selaginella*. Microscopically thin layers of transparent material in the leaves back reflect light rays we see as blue. Some leaves contain too much water, which destroys the structural colour machine, in which case the green pigment chlorophyll dominates.

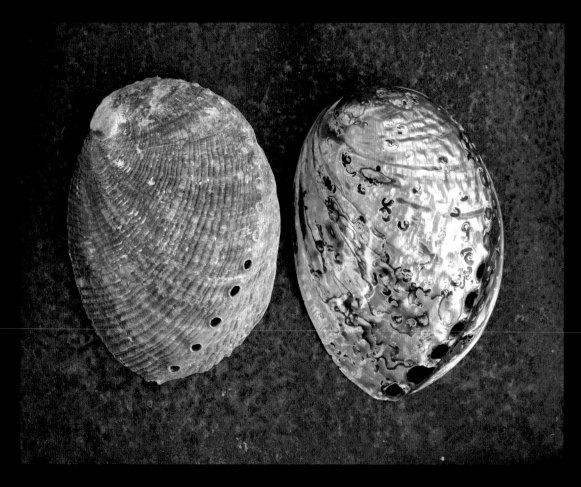

[left] Abalone shells, viewed from their outer side, as predators would see them. The shell is made up of microscopically-thin layers to make it strong and robust. Incidentally, these transparent, thin-layers also reflect light and become a form of structural colour (albeit not an efficient example). Since this structural colour would alert predators and cause the abalone more harm than good, a pigmented, camouflaged covering has evolved. This covering has been removed in the shell on the right.

[right] *Structural Colour Bodies*, structural coloured paint on canvas, Andrew Parker, 2019.

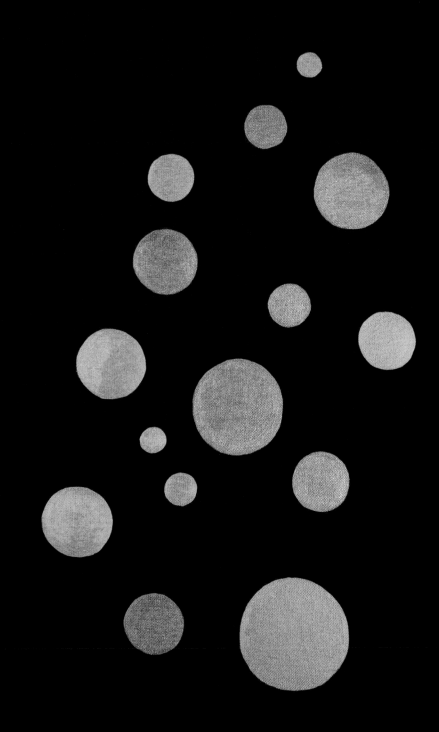

4
The quest to reproduce structural colour in natural history

In the nineteenth century, artists recognised that the pigments in their paints failed to capture the dazzling appearance of a structural colour of, for example, hummingbirds. During this period, the ornithologist and bird artist John Gould developed a new illustrative technique to accurately depict the structural colour of hummingbirds. He was partly successful. Gould's technique involved three stages: depositing a base layer of gold or silver leaf, adding a layer of translucent paint (of the main colour of the plumage), and finishing with a 'secret' glaze containing honey. The gold or silver leaf ensured a highly reflective, mirror-like effect, the paint filtered through the desired colour, and the glaze caused the reflected rays to spread out (preventing a spot reflection). More recently, hummingbird feathers were found to contain microscopic structures that very precisely reflect sunlight; 'nanotechnology' way beyond the capabilities of a nineteenth-century artist.

[right] *Hundred-Year-Old Colour*, Andrew Parker, 2019.

A re-constructed display cabinet of Victorian/Edwardian hummingbirds: taxidermy hummingbirds, showing iridescent or structural colours. These colours are formed from the reflection of light from stacks of microscopic rods or plates inside the feather barbs and barbules.

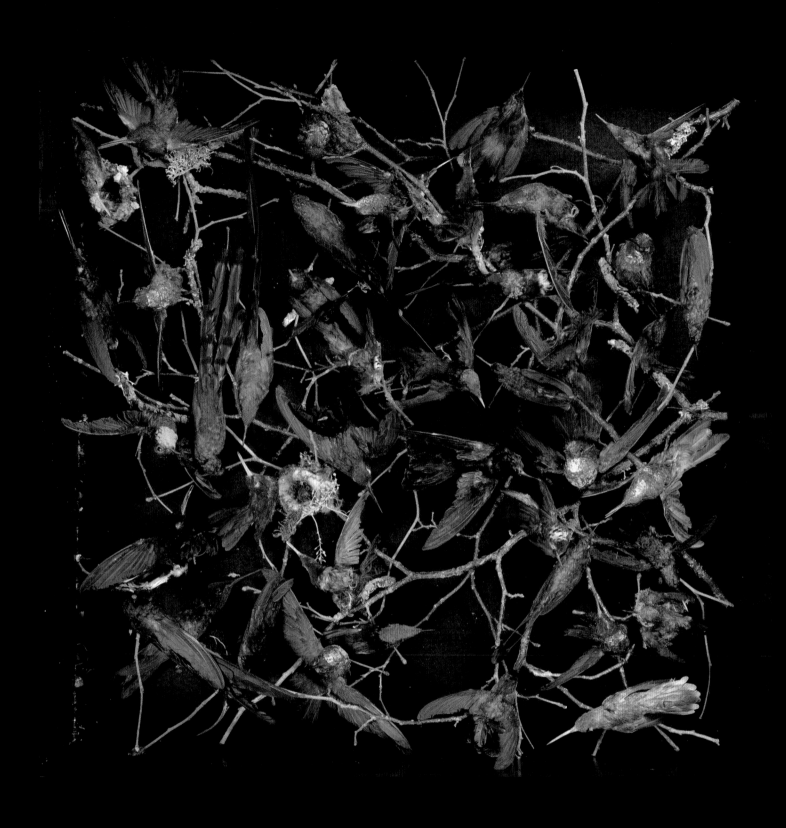

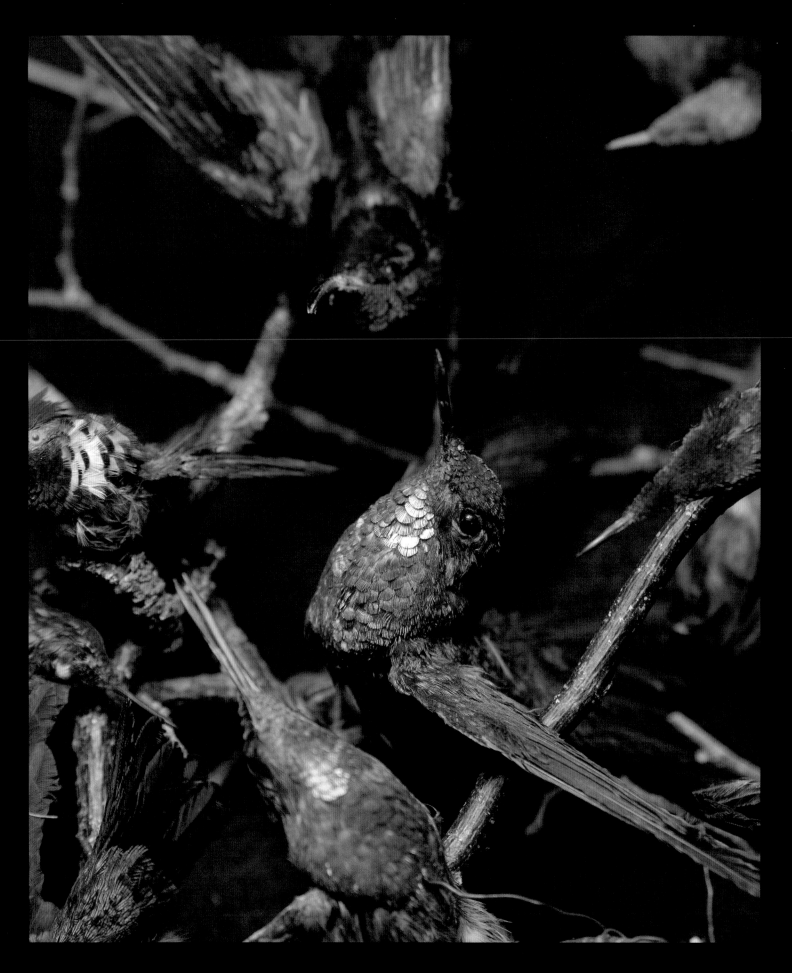

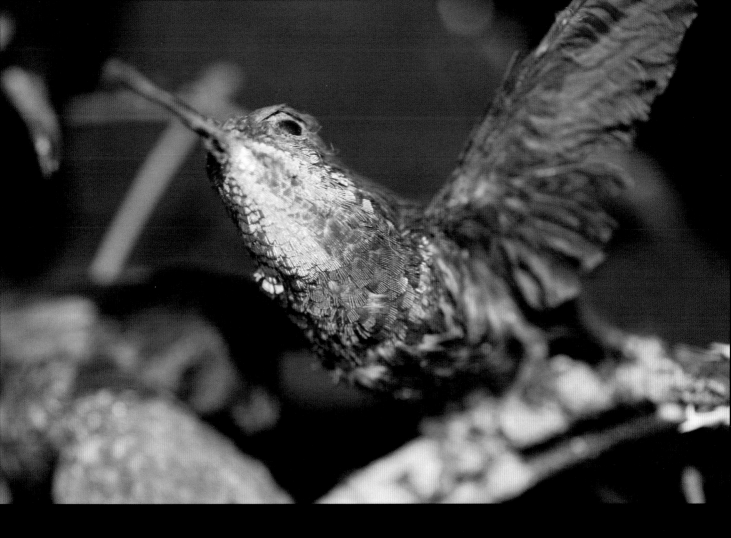

[left and above] Details from the
re-constructed hummingbird
cabinet, *Hundred-Year-Old Colour*.

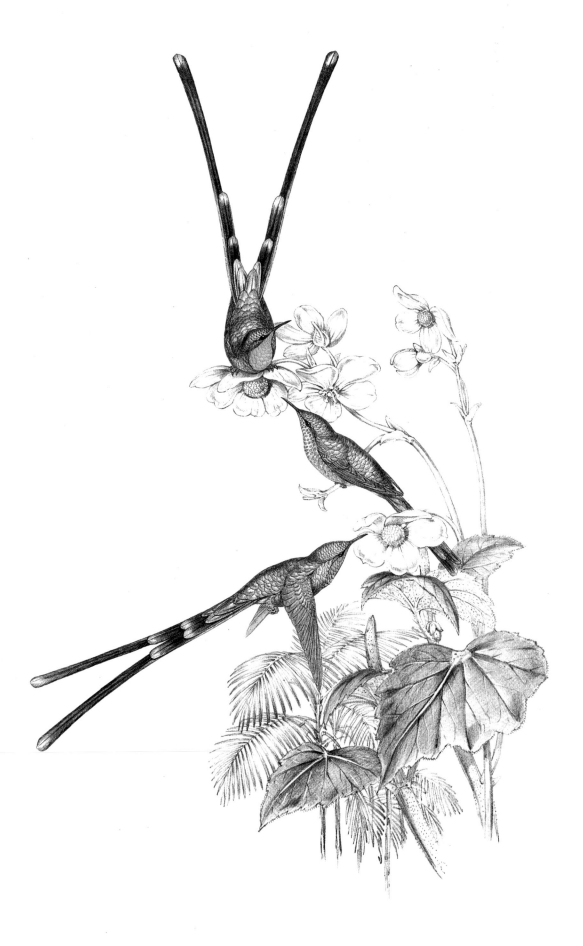

[left] A preparatory stage for a plate in John Gould's *A Monograph of the Trochilidae, or Family of Humming-birds.* An original plate of one of Gould's hummingbirds, *Lesbia nuna* (the green-tailed trainbearer), in a pre-publication stage: a black and white print with gold leaf added in some areas of the plumage, awaiting over-painting and a honey-based glaze.

[right] A published plate from John Gould's *A Monograph of the Trochilidae, or Family of Humming-birds*. A finished plate of *Cynanthus smaragdicaudus* (the green-tailed sylph), where some parts of the birds' plumage are coloured with pigmented paints only, and other parts contain the combination of gold leaf, translucent paint and a glaze. In their slight change in visual effect with angle of viewing, the gold leaf parts offer a sense of something unusual (a departure from pigments), albeit not scientifically accurate representations of the hummingbird's structural colours.

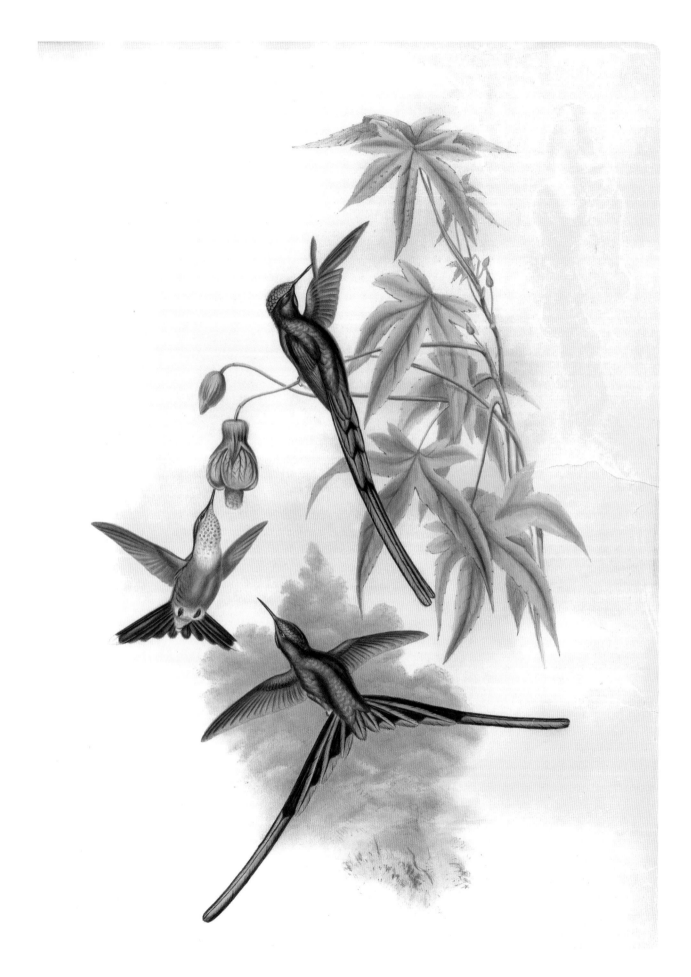

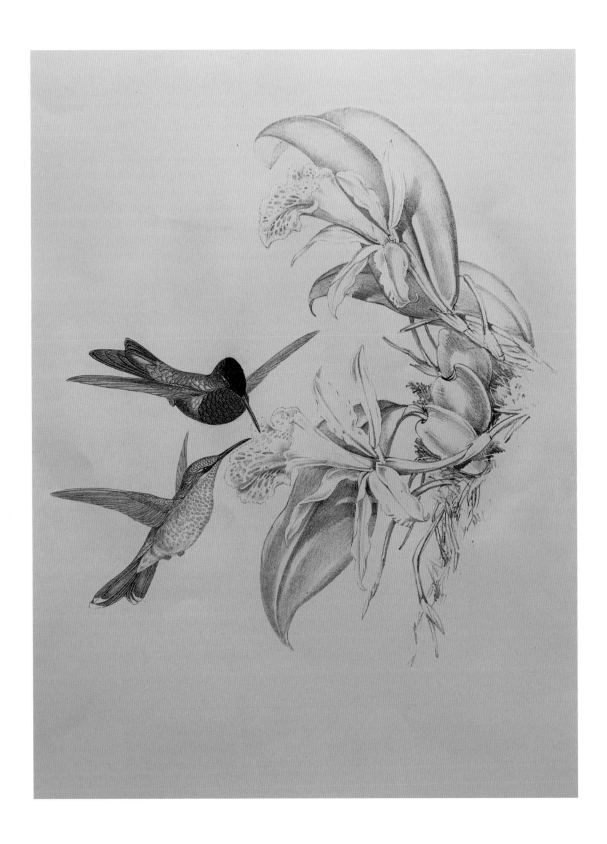

[above] and [right] Another pre-publication plate from John Gould's hummingbird volume, showing *Heliodoxa leadbeateri* where part of the plumage has been coloured with gold leaf and, in part, overpainted with a translucent blue paint. The images are taken perpendicular to the page (normal) and at a 30° angle to the normal, in both images light is incident at a 30° angle to the other side of the normal. The gold leaf reflects light in the manner of a mirror.

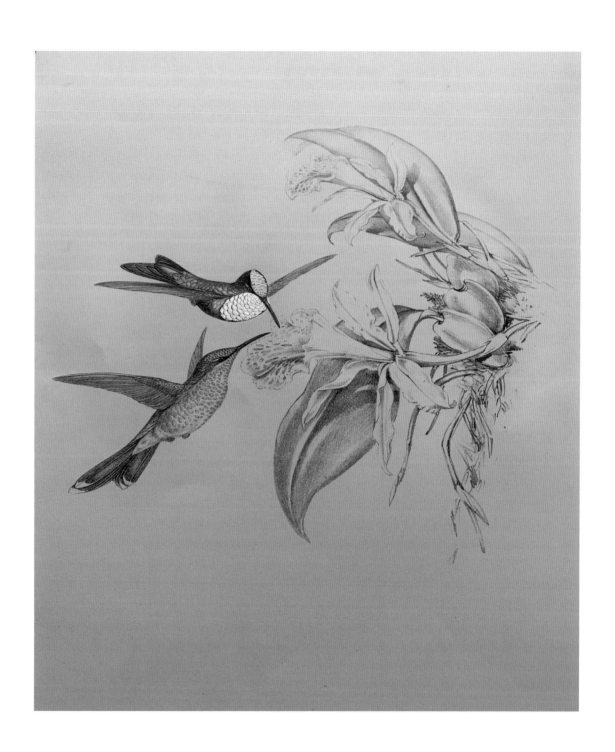

5
Pure Structural Colour – the world's brightest colour

Pure Structural Colour is a mimic of the type of structural colour that has evolved many times, independently, in nature to appear the brightest type of colour to the eye. It has co-evolved with the visual systems of animals to result in the ultimate form of colouration. By 'colour' and 'colouration', I refer to a way of colouring an object so that it appears similar from all directions – the complete object appears coloured. A different type of structural colour exists in some of our commercial products, which appears as a bright flash of light which disappears or changes sharply in hue as we move. This has become synonymous with gaudiness – a pitfall for structural colour.

Pure Structural Colour, on the other hand, can appear a similar hue from most angles of viewing. It is made from transparent materials with a microscopic structure or architecture. This structure reflects light rays of a single hue so that they are spread out into many directions. Therefore, an object coloured in this way can appear a similar hue from many directions. This multidirectional property, combined with the near-optimal reflectivity, results in a bright but luxurious, velvety colour that is alluring to the eye. This is the structural colour effect of many animals and plants. The analogue that has now been reproduced by human engineering, is termed Pure Structural Colour.

The making of Pure Structural Colour
For decades, scientists have sought to make Pure Structural Colour. A disconnect between science labs and engineering factories led to false hopes, where tiny (millimetre-sized) surfaces of structural colour were made but at unfeasibly high costs for industry. The problem was that infinitesimally small nanostructures were involved, which could never be made economically in high volumes. The breakthrough for Pure Structural Colour came when it was realised that we no longer needed the expensive, specialised clean rooms as used for scientific research, and instead we could make this type of colour in ordinary factories. Now Pure Structural Colour can be made as *large*, flat surfaces.

Still, Pure Structural Colour is much more expensive than a tin of paint. But for applications in select commercial products, and in artworks, the extra expense pays dividends when the eye-catching hues emerge from the manufacturing machines.

[right] Two samples of Pure Structural Colour on silicone rubber, showing the slight change in colour as the material is distorted and, consequently, the orientation to the viewer varies significantly.

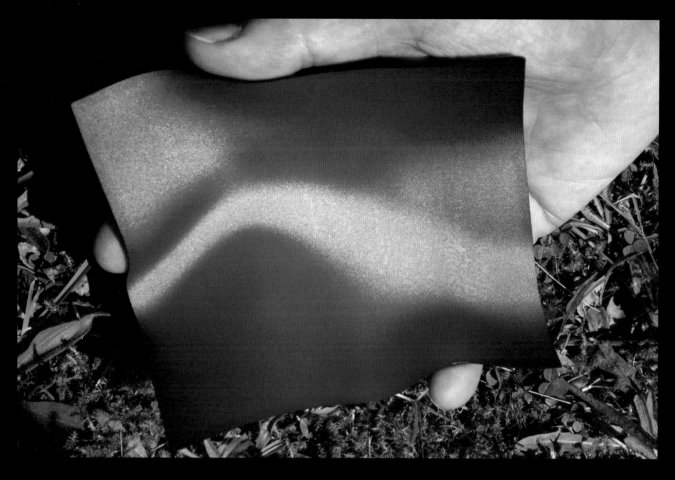

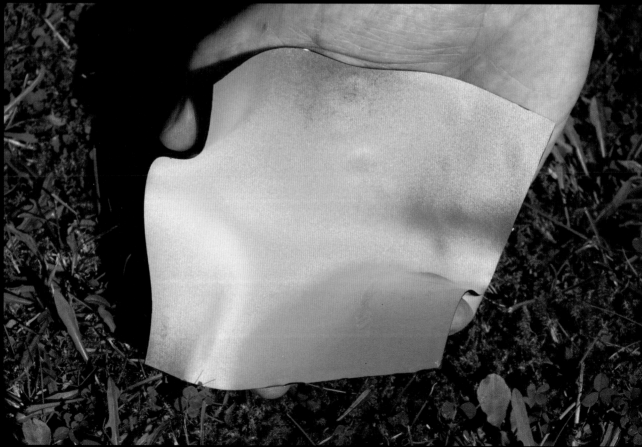

6
Coral G. Guest's *Pollia*

The eminent botanical artist, Coral G. Guest, was commissioned to produce the first painting of a structurally coloured plant employing its technically correct structural colour mechanism. Pure Structural Colour was made in the form of tiny, barely visible flakes, and Coral sought to find a suitable, transparent embedding medium so that the mixture would become a structural colour paint. This formed a challenging experiment indeed, but Coral's results were remarkable.

In this chapter, Coral's painting and some of her experimental colour swatches are revealed. Below are Coral's notes on her experience during this project – her words best capture the process of her work and her experience with Pure Structural Colour flakes.

Observational notes during the painting of the *Pollia condensata*
Coral G. Guest, 19 October 2019

A synthesis of science and art
Developments in artists' paint colours occur when artists have a need and scientists have the power to formulate the materials to fulfil that need. Landmark moments in the history of art are often connected to this kind of symbiotic relationship. The high permanence quinacridone family of artists colours, introduced by Winsor and Newton in the 1950s, were originally developed by the car industry. These were translated into artists' watercolour paints with the flower painter in mind. They replaced the duller alizarin group of colours and

facilitated the depiction of the vibrant magenta and purple hues that are present in countless flower petals.

The new development of Pure Structural Colour flakes by Andrew Parker has enabled the artistic depiction of structural colouration as it exists in the natural world. This is a recent example of a synthesis between science and art.

The commissioned painting, of the fruit of *Pollia condensata*, combines the innovatory preparations of Pure Structural Colour flakes with conventional acrylic paint. This artwork is the first creative experiment to pave the way for a future formulation of a brand-new paint system for artists.

**The choice of subject matter
– *Pollia condensata***
The tiny blue berries of this plant, also known as the marble berry, were chosen as the subject matter for their incredible colouring due to structural colouration in the body of the fruit. What is also noticeable about *Pollia* fruits is that they not only hold structural colour in their form but also have a very shiny and reflective surface. For the botanical painter, the combination of these two characteristics demands the depiction of both colour and surface reflection.

The scale and composition of the painting
Pollia condensata berries were acquired from Dr Shirley Sherwood, specifically for the purpose of this commission. Each berry (capsule) is similar in form, but not identical, being hard, ovoid or spherical, and in a range of

closely related sizes from 2–5 mm in diameter. The plant has pale pink or white flowers on a stem about 60 cm high.

The commissioned painting depicts an enlargement of two berries, still resting upon their desiccated stalks. This choice reveals the dichotomy between the wizened stoloniferous stems and the polished appearance of the berries, drawing attention to the fact that the berries can sustain their unique colour and form for many years after they have fallen from the living plant, which is deciduous.

During the planning stage of the work, all options were possible regarding the size of the completed painting. I decided to enlarge the tiny berries to a grandiose size, for two main reasons. Firstly, the size would have an aesthetically dramatic appearance in a modern gallery space. Secondly, the actual size of the Pure Structural Colour flakes to be used in the artwork would be compatible, and appear realistic, within this size of image.

To prepare for this large painting, a range of observational translations were employed as well as graphite and pen thumbnail sketches. Colour swatches were prepared with Pure Structural Colour to determine the possible mixtures of conventional colours and the placement of the Pure Structural Colour flakes with the conventional paint. Finally a small colour study was undertaken, used as a spontaneously painted impression of how the final painting would appear.

Daylight in the studio
Most available images of *Pollia condensata* fruits are made from flash photography, and show a rounded highlight of brightest white that bounces from the rotund shiny surface of the form. Such images are not naturalistic.

As an observational painter, I work slightly differently from the botanical illustrator in that I paint in natural daylight and do not use artificial light. I also paint directly from life and avoid photographic imagery as reference material because it does not concur well enough with the living specimen.

The two berries in the painting depict a bright white highlight, as it appears on their reflective surface, as an obscure oblong shape. This indicates that the light source which illuminates the fruits is from a daylight window.

My work conforms to a naturalistic ethic which adjusts itself sympathetically to every plant I paint. This is achieved through careful observation of its purpose and general demeanour. *Pollia* fruits generally grow upon the forest floor in the African continent and are seen and eaten by the indigenous bird life, in spite of their lack of nutritional value. The birds, who also collect the berries to adorn their nests, are attracted to the shiny blue colouring of the berries as seen in natural daylight, as it dapples and flows through to the forest. This painting is not about analytical plant identification, it is about faithful observation and depiction from a naturalistic point of view.

Observations of structural colour within the *Pollia* fruit
Using natural daylight allowed the rendering of a rich blue that is composed of a visual collocation of several similar and distinct blues. These are primary hues of blue and those that are biased towards green and magenta. The magenta colours noticeable in the berry are not an aspect of our visible colour spectrum, but a combination of red and violet, which stand at opposite ends of our visible spectrum.

Pollia fruits, when seen under magnification, transcend one hue of blue to create shifting combinations of many blue hues. These perceptible colours appear fused within the body of the fruit when viewed from alternate angles. This effect is also present in the Pure Structural Colour flakes used in my painting and is a characteristic of structural colouration.

This combination of factors gives the berry its mesmerising, luminescent and metallic appearance. My aim as a painter was to observe and depict the placement of these colours, with their fusion and subtle divisions, as they are found beneath the reflective surface that encloses the arrangement of structural colour in the berry's body.

On even closer appearance, the inner arrangement of structural colouration, under magnification, reveals a pixelated appearance beneath the mirrored surface of the fruit. The Pure Structural Colour flakes I was provided with were formulated to reflect blue tones and hues that perfectly represented those present in the berries themselves. When laid onto

...the surface of a painting they have a corresponding appearance.

Combining Pure Structural Colour flakes with conventional professional acrylic paint and mediums

The fundamental tonal image of the colour and form of the *Pollia* berries was achieved within the artwork by building many thin layers of conventional artists' acrylic colour. A final layer of Pure Structural Colour flakes, mixed with a conventional artists' acrylic medium, was then applied.

The concern at this point of the process was to depict an image of the berries based on the combined use of both conventional paint and structural colour. However, the application of the structural colour flakes could not be easily controlled because they are not yet formulated into a suitable professional quality paint that can be successfully modelled with a brush. Once mixed and suspended within the acrylic medium, the flakes needed to be applied with a palette knife, or a silicone brush, simply because they are easily dispersed and lost within the hairs of a conventional brush. The flakes also needed to be used sparingly and very carefully, as they are currently very expensive to produce.

Picturesque conclusions

It has often been noted by scientists that the pixelated appearance of *Pollia* fruit, when seen through magnification, can be compared to that of a pointillist painting by George Seurat (1859–1891), who analysed the impression of colour and light in his work.

As an alternative, I view the round *Pollia* berry as having the appearance of a universe within its form. To me it holds a scaled down world of vast space containing visible points of light. A mystical viewpoint may interpret this as a macrocosmic reflection within the microcosm of the fruit.

Perhaps one might speculate what the visionary English artist and poet William Blake (1757–1827) would have thought of the presence of structural colouration in the natural world, which he certainly would have seen in butterfly wings and ground beetles. And I can't help but wonder what his reaction to Pure Structural Colour flakes in paint form might have been. The first four lines of his poem *Auguries of Innocence* might be indicative:

To see a World in a Grain of Sand
And Heaven in a Wild Flower
Hold Infinity in the palm of your hand
And Eternity in an hour.

Pollia, acrylic and Pure
Structural Colour flakes on
canvas, Coral G. Guest, 2019.

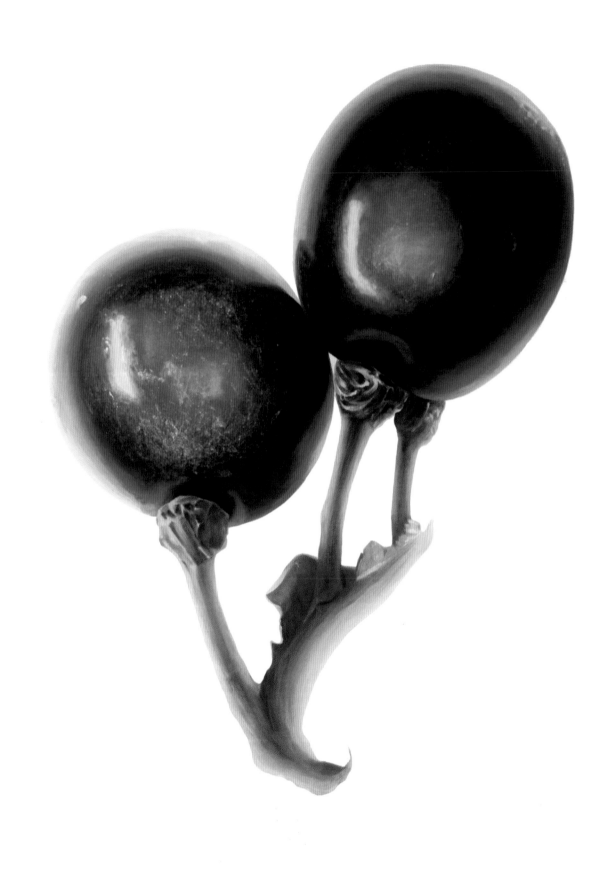

7
Kaleidoscope

A kaleidoscope was made using precision optical components and an oil-filled chamber containing glass elements, each coloured with pigments, conventional structural colour or Pure Structural Colour. A customised, motorised stage was built to house the kaleidoscope, complete with a ring of white LED lights to illuminate the coloured elements equally. A computer-controlled camera was added to the apparatus to capture images through the eyepiece as the kaleidoscope turns, so that live images could be projected onto a screen.

As the kaleidoscope turns, the ever-changing patterns provide a motion picture, and a platform for the different types of colour machineries to be compared. The pigments assemble a backdrop of coloured shapes. Upon this, intermittent bright flashes distract the eye, which result from the conventional structural coloured elements. Pure Structural Colour appears somewhere between these two effects, but unlike the flashes can be seen equally when oriented in multiple directions. In general, structural colour will appear brighter than pigments under the same viewing conditions. In a dark understorey, where pigments fade, some plants and animals make themselves visible through structural colour.

[pages 57–63] *Kaleidoscope of Nature's Colours, I–IV*, Andrew Parker, 2019.

Images through the eyepiece of a kaleidoscope displaying colour produced by pigments, conventional structural colour and Pure Structural Colour.

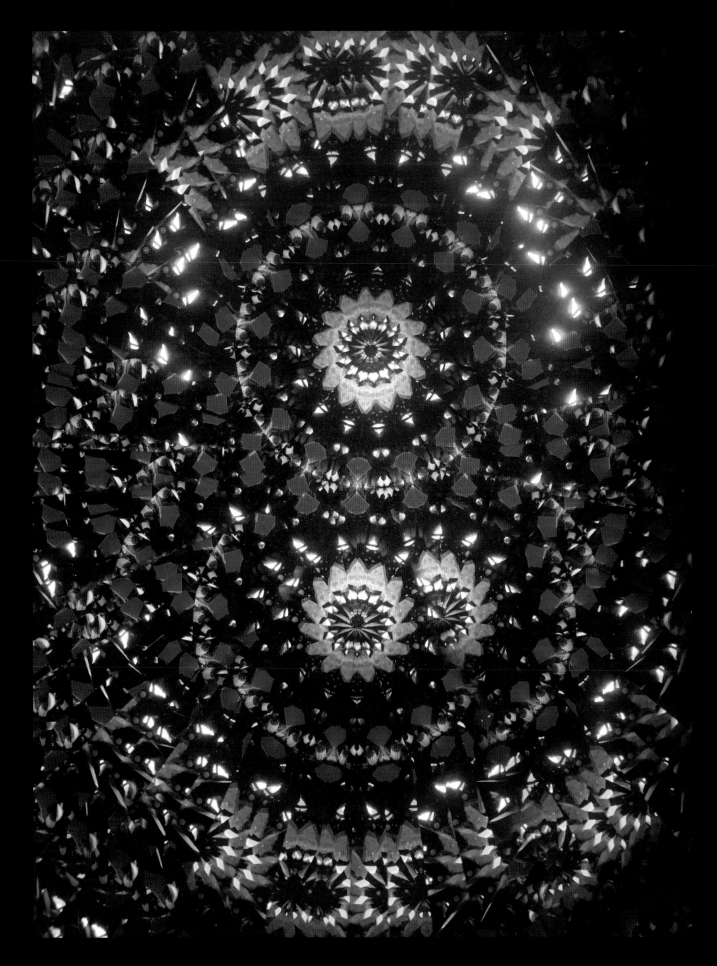

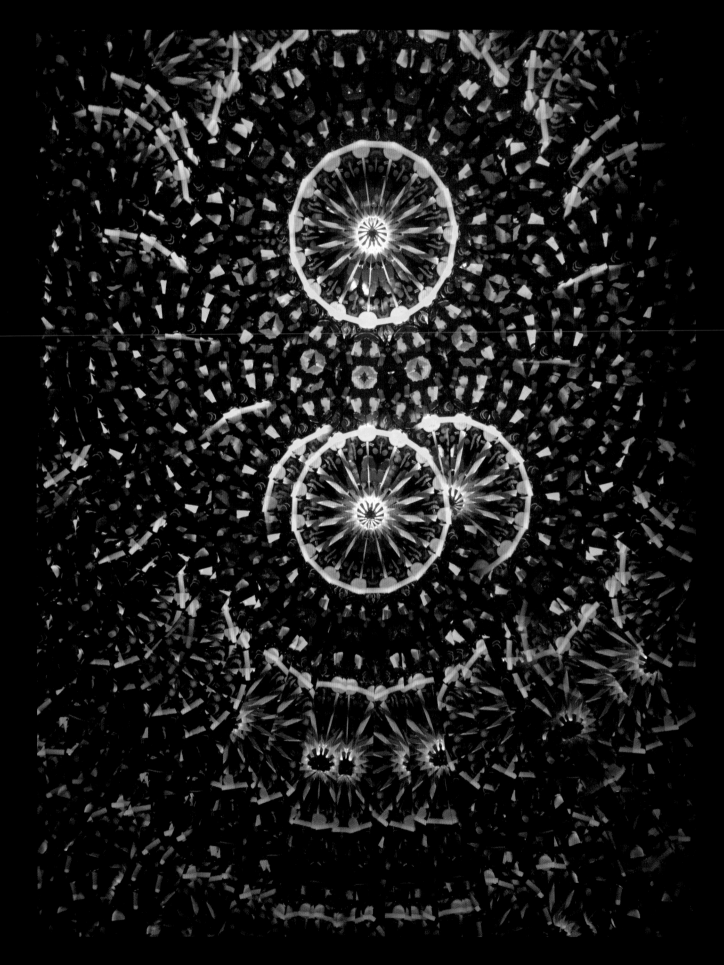

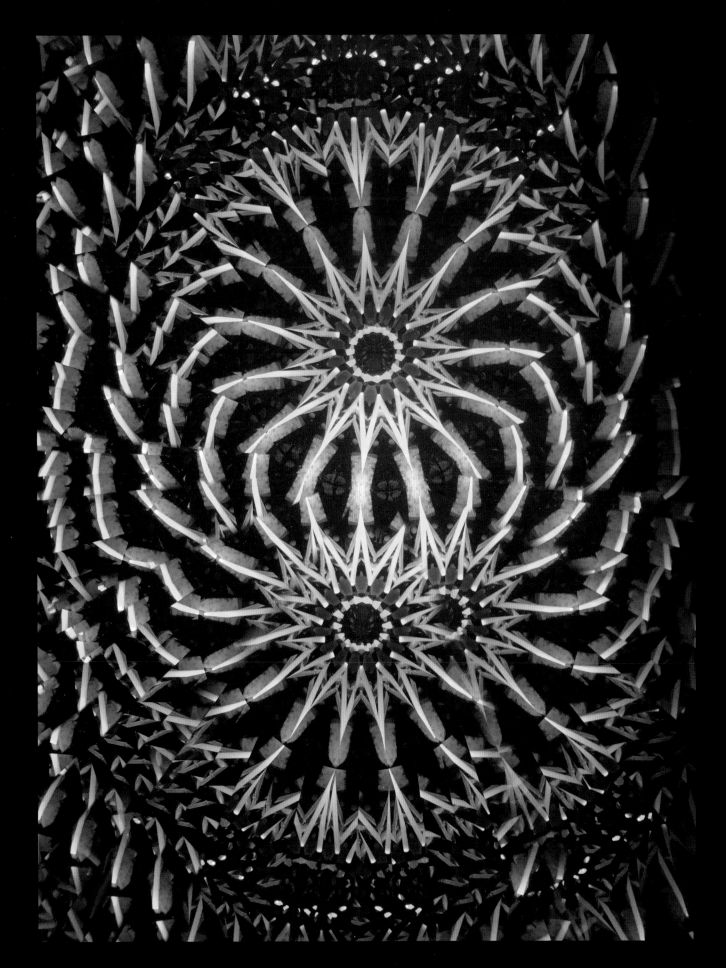

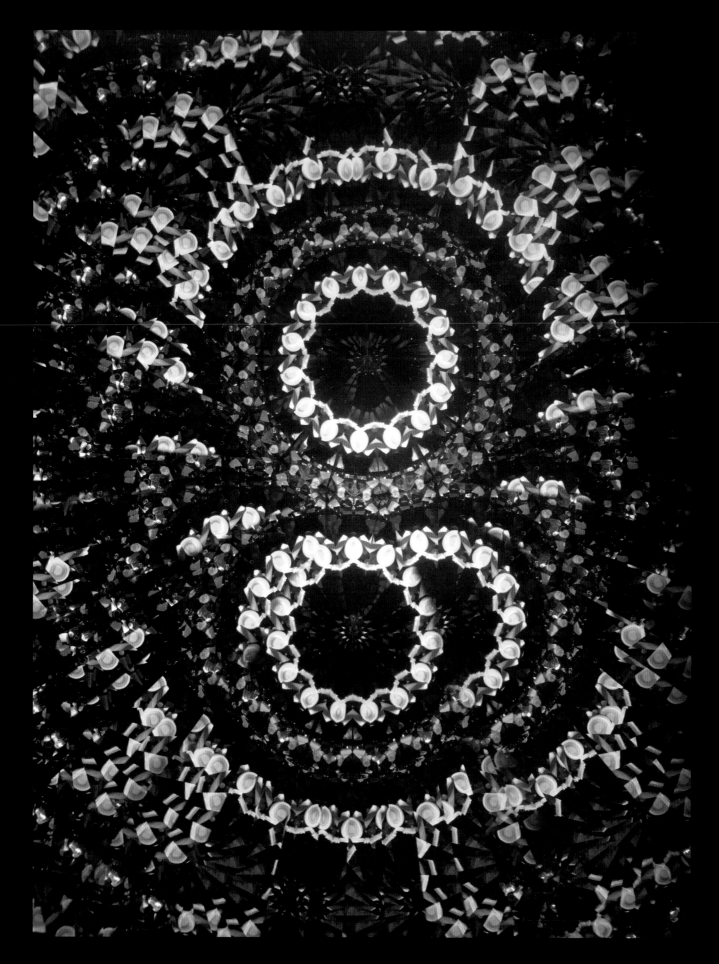

8
Pure Structural Colour and Thornton's *Temple of Flora*

Pure Structural Colour is made as a continuous surface of colour. The hue is dependent on the dimensions of the architecture of the microscopic structures involved. Consequently, the colour can be finely tuned, while retaining the ultra-bright yet velvety effect. In this chapter, seven hues were made with optimal precision. They were selected based on seven disparate, and charismatic hues found in *The Temple of Flora* by the physician Robert John Thornton (1807).

Thornton conceived his tome at a time when the fashion was gothic. This led him to shun the trend in botanical illustrations, where plant subjects were set against white backgrounds or their natural environments. Rather, his artists were charged with capturing the 'spirit' and 'personality' of the plants, particularly their darker, corporeal sides.

The often bleak and dramatic settings of Thornton's images contrast with the bright colours of the plants themselves, for heightened creative effect. This seemed a perfect partner for Pure Structural Colour, where optimal effect is achieved when the colour is juxtaposed with a black background.

Thornton considered plant colours as an aspect of persona. He commented on the first of these plates, *The Dragon Arum*, that 'the clouds are disturbed, and everything looks wild and sombre about the dragon Arum, a plant equally

as poisonous as foetid.' Interestingly the violet colour of this plant, reproduced separately and in ultimate brightness in Pure Structural Colour, reminds some viewers of death. Pure Structural Colour by itself may stir emotions in the manner sought by Thornton, through his use of fearful, gothic settings.

Rather than breaking the surface into tiny flakes, as was the case for Coral G. Guest's *Pollia* painting, the artworks in this and the following chapters employ continuous surfaces of colour. The seven works in this chapter feature Pure Structural Colour in different hues, manufactured to high specifications and scientific accuracy. Proportions found in 'geometry in nature' were employed in the coloured rectangles and the frames. These are proportions that have evolved independently multiple times in plants and animals, and may form shapes that the eye has evolved to appreciate. Indeed, when compared with alternative shapes (squares and other rectangles), the geometry in nature rectangles were found to appear the most captivating.

When the artworks themselves are viewed, the additional brightness of the colour targets shortcomings in our visual system to generate the effect of movement – we think we are seeing something we are not. Alas, the reproductions in this book are made using pigmented inks, and so some of the visual effect is lost.

[right] Juxtaposed rectangles of Pure Structural Colour in complimentary combinations with optimal effect, causing the experience of movement, where they adjoin, in the eye of the viewer.

[overleaf, pages 66-79] Plates reproduced from *The Temple of Flora* by Robert John Thornton (1807) are shown beside examples of Pure Structural Colour influenced by the plate's dominant hue. In order, the plates are: *The Dragon Arum* (violet), *Hyacinths* (mid blue), *The Blue Egyptian Water Lily* (cyan), *The Maggot-Bearing Stapelia* (green), *The Night-Blooming Cereus* (yellow), *The Queen Flower* (orange) and *Tankerville's Limodorum* (crimson).

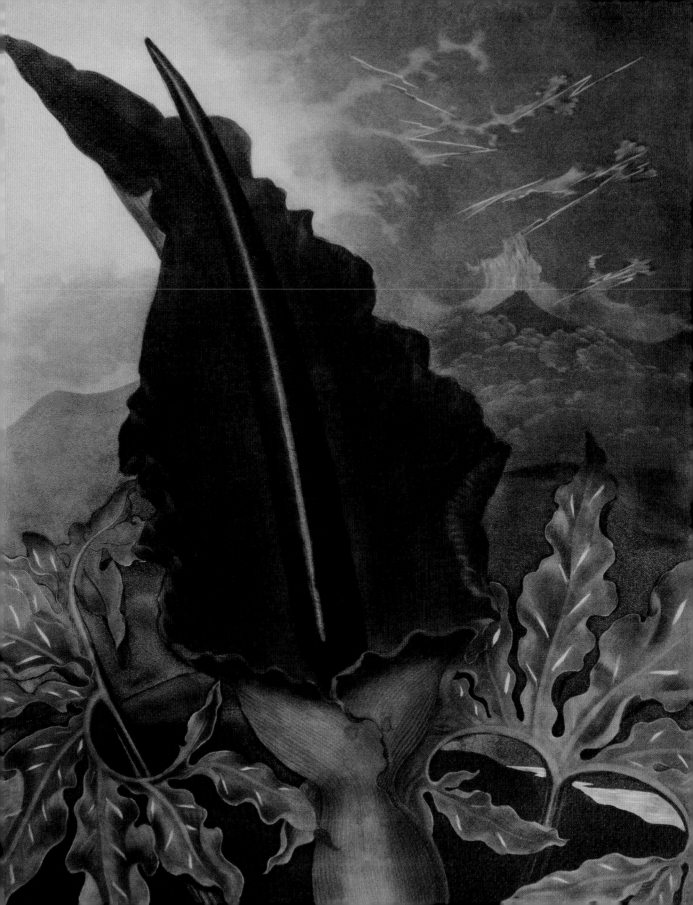

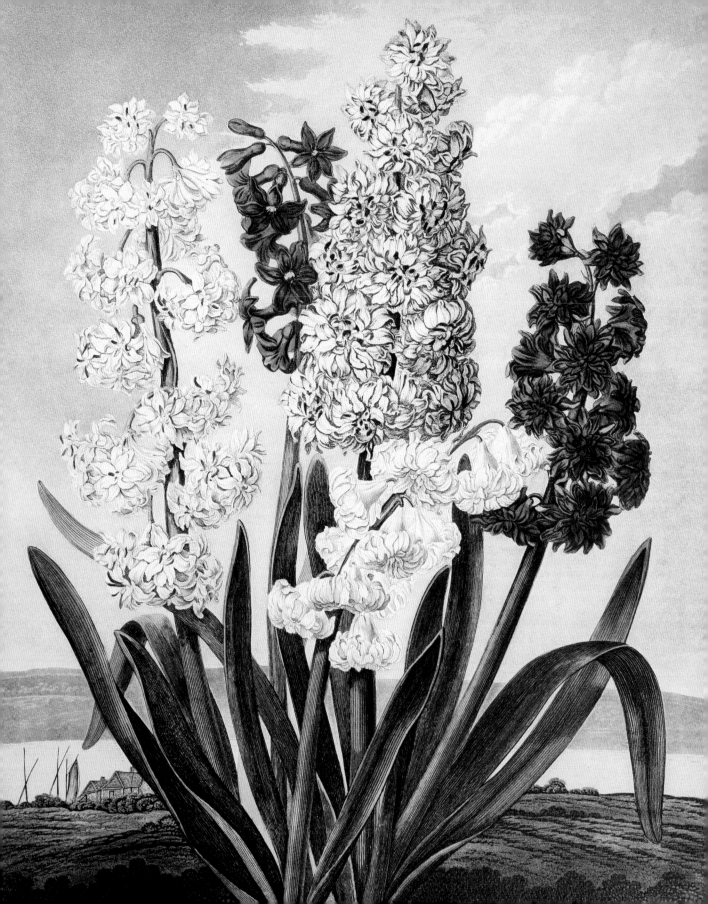

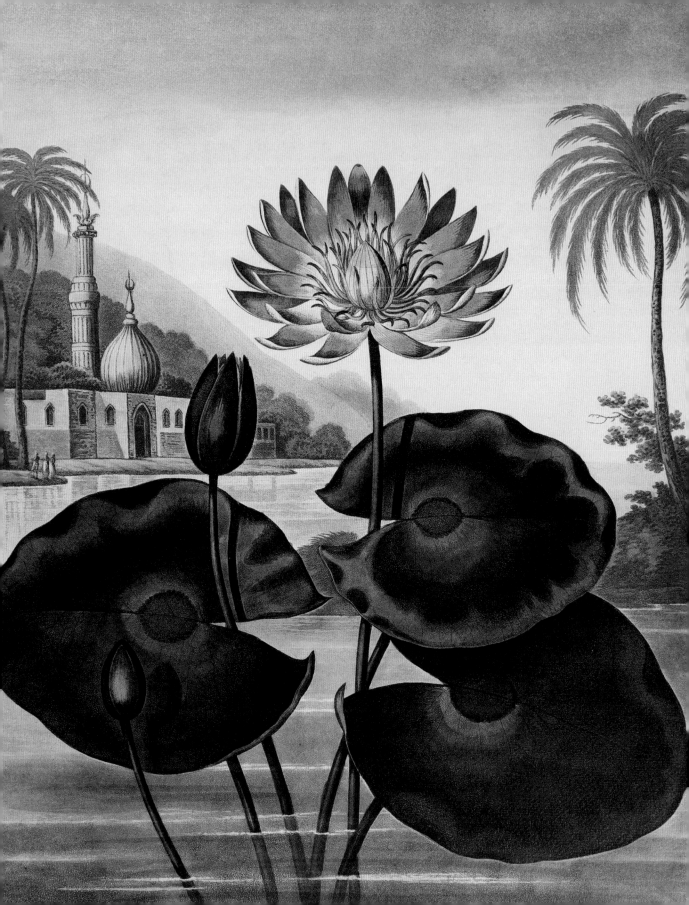

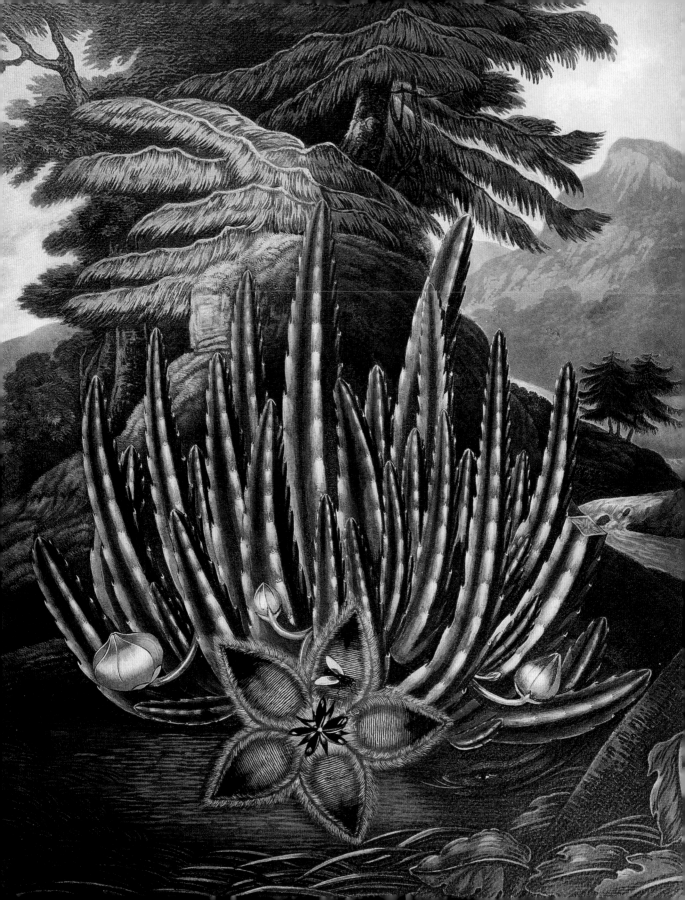

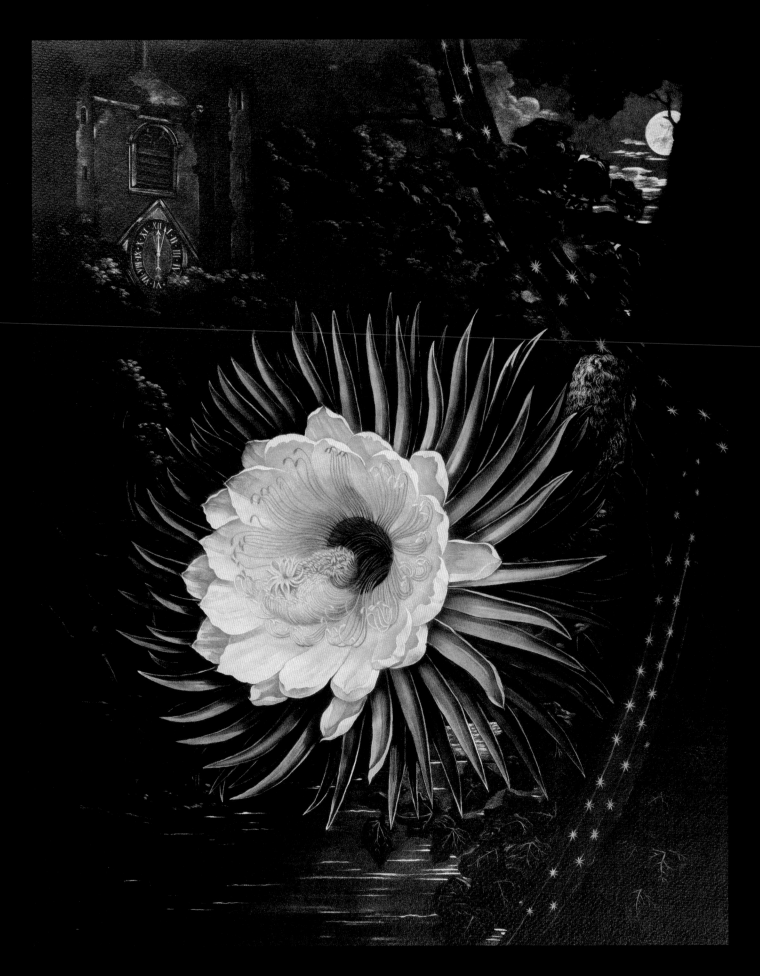

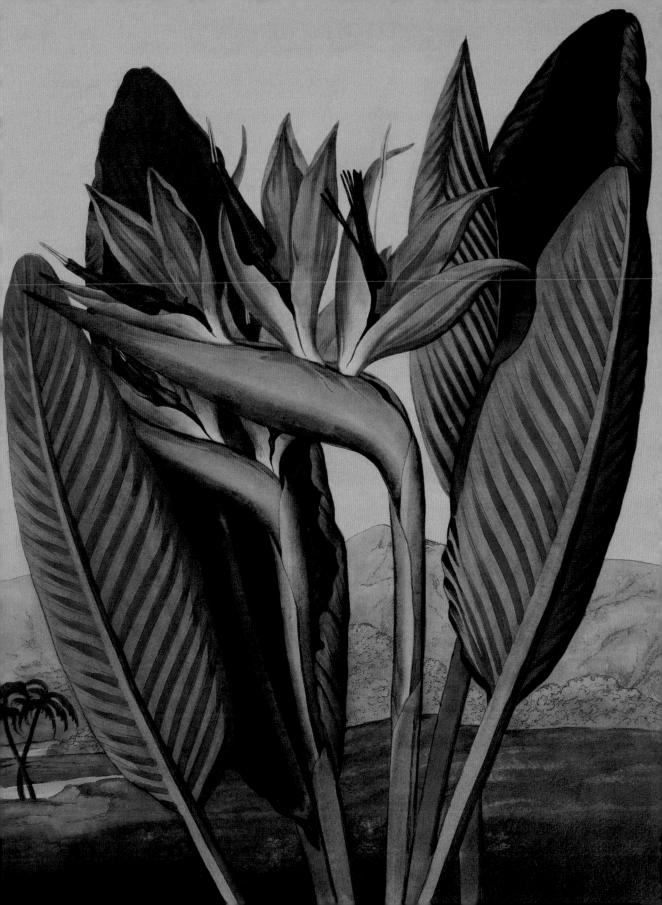

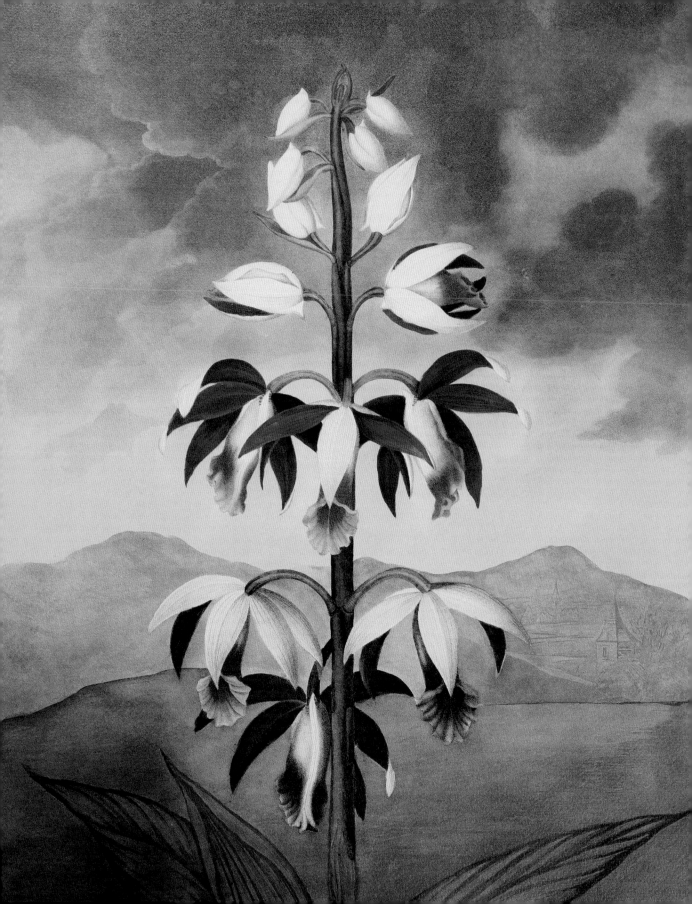

9
Pure Structural Colour artworks

Artworks using small pieces of Pure Structural Colour were made on composite, black canvases, up to 3 m long. As works using Pure Structural Colour were developed, I began to depart from larger pieces of the colour to smaller pieces, the size of coins. Placed sparingly on a black background, these smaller pieces at once exhibited a jewel-like quality. The smaller pieces of Pure Structural Colour offer a lesser perception of movement, but instead suggest that we are viewing something special, even precious. To me, this represented the rows and columns of jewelled beetles or butterflies in the trays of a museum's collection cabinet. To others, they are gemstones displayed in black velvet cases. To heighten the effect, the 'blackest black' paint available was used.

The patterns in the three large artworks illustrated in this chapter were inspired by natural events. In *Emerging Fern* (pages 84–7), Pure Structural Colour dots and eye-shapes represent the colour production machines in a fern plant, emerging as light levels rise in spring and colour becomes increasingly important to life. The fern plant itself, though, has no colour; its colour machines factories manipulate sunlight so that we see it as colour.

In *Stimulus* (pages 88–91), Pure Structural Colour dots and eye-shapes take the form of a light waveform (cyan). Evolution responded to the sun's rays with the eye. The eye converts these rays into different colours, such as violet, red, green and orange.

In *Life's Big Bang* (pages 92–5), Pure Structural Colour dots and eye-shapes explode outwards, each representing the visually adapted species that evolved during the Cambrian explosion, the Big Bang of evolution. During this event, around 520 million years ago, animal bodies rapidly evolved into recognisable, colour-adapted forms due to the appearance of the evolutionary arms race's greatest weapon – the eye. A detail of each artwork is shown from a different angle, illustrating the slight change in hue in the Pure Structural Colour pieces (some change colour more than others).

Prior to these larger works, three smaller artworks are illustrated in this chapter. The first is *Seven Discs*. Here, small discs of Pure Structural Colour, made with precision in seven spectral hues, were organised in dimensions according to geometry in nature. Interestingly, when alternative spacings and patterns of the discs were used, and when set in frames not employing geometry in nature, the visual impact was lessened.

The second and third, smaller artworks illustrated here are *Eye Geometry* and *Inverse Eye Geometry*, where geometry in nature (as influential in Islamic architecture, for example), for example was used to carve a pattern into the circular 'iris' of a larger eye shape. Two complimentary colours were used to express the pattern; their positions are switched in the two artworks. Sometimes, the boundaries between two hues of Pure Structural Colour cannot be well resolved by the eye, causing enhanced effects of movement or shimmering.

[right] *Seven Discs*, Pure Structural Colour on card; multiple artists, 2018.

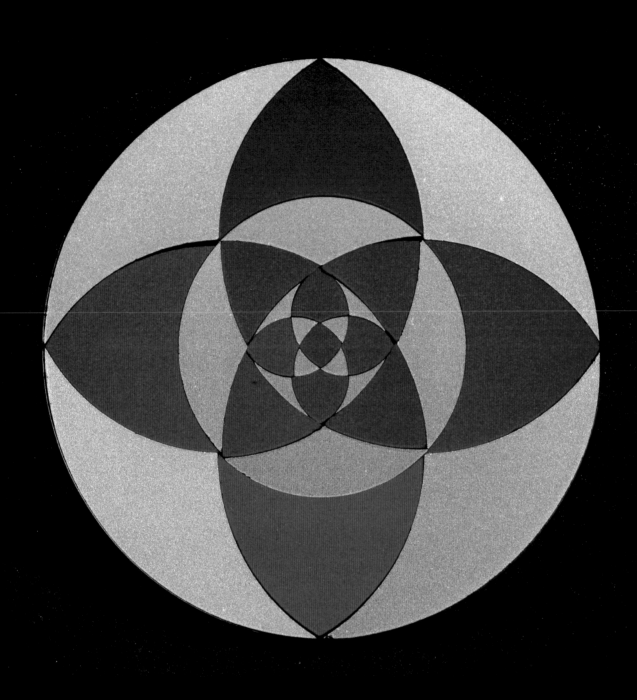

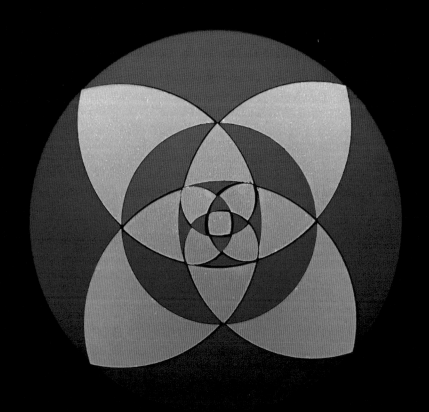

[left] *Eye Geometry* and
[above] *Inverse Eye Geometry,*
Pure Structural Colour on acrylic
sheet, multiple artists, 2018.

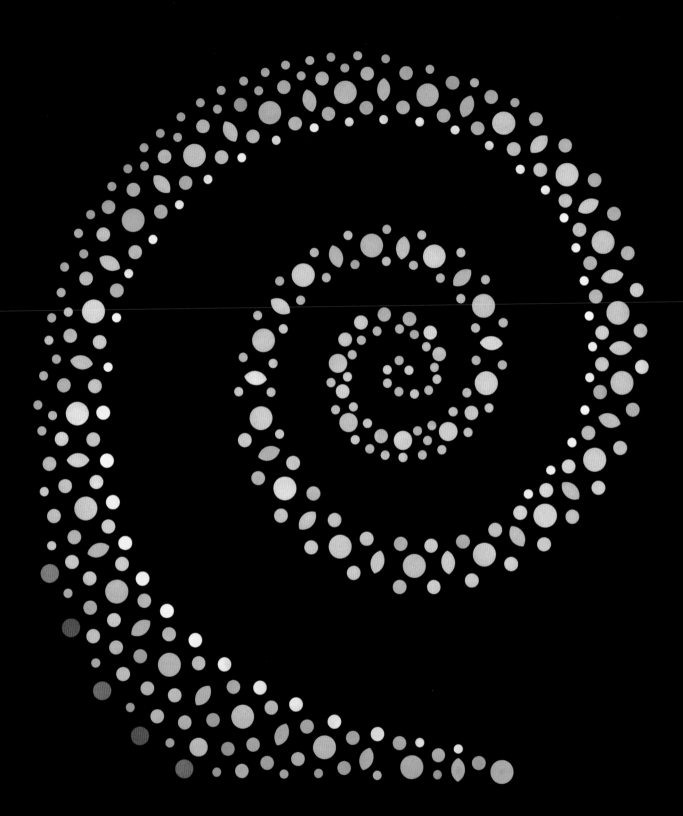

Emerging Fern, Pure Structural Colour shapes on canvas (1.6 m x 1.6 m), Andrew Parker, 2019.

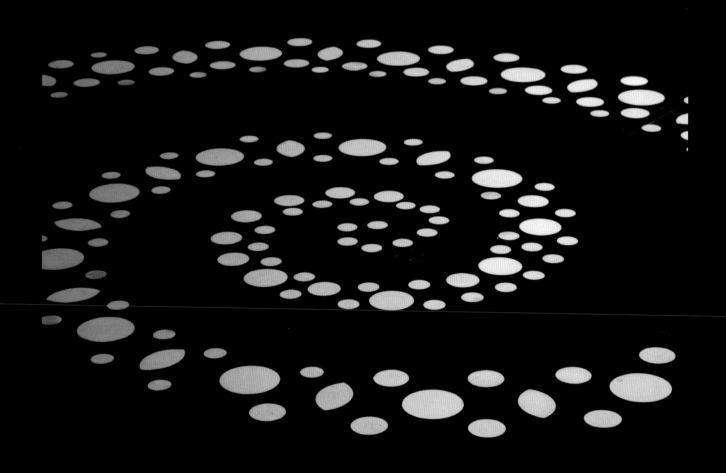

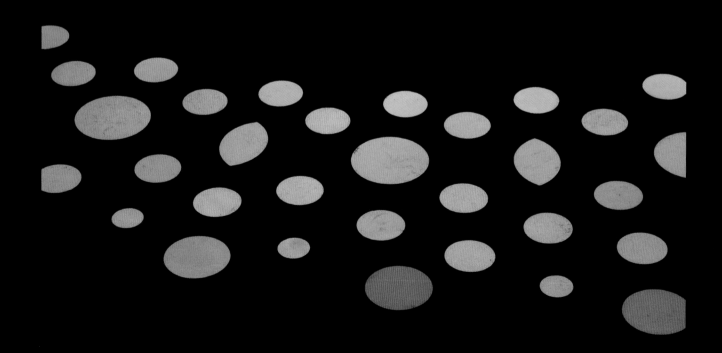

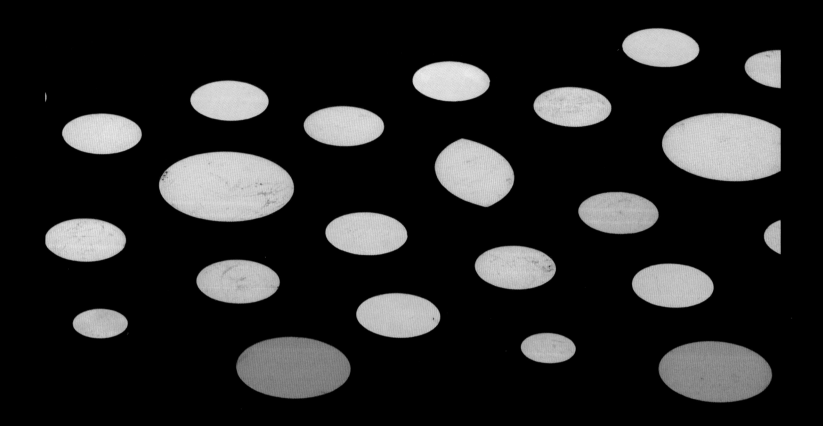

Details from *Emerging Fern.*

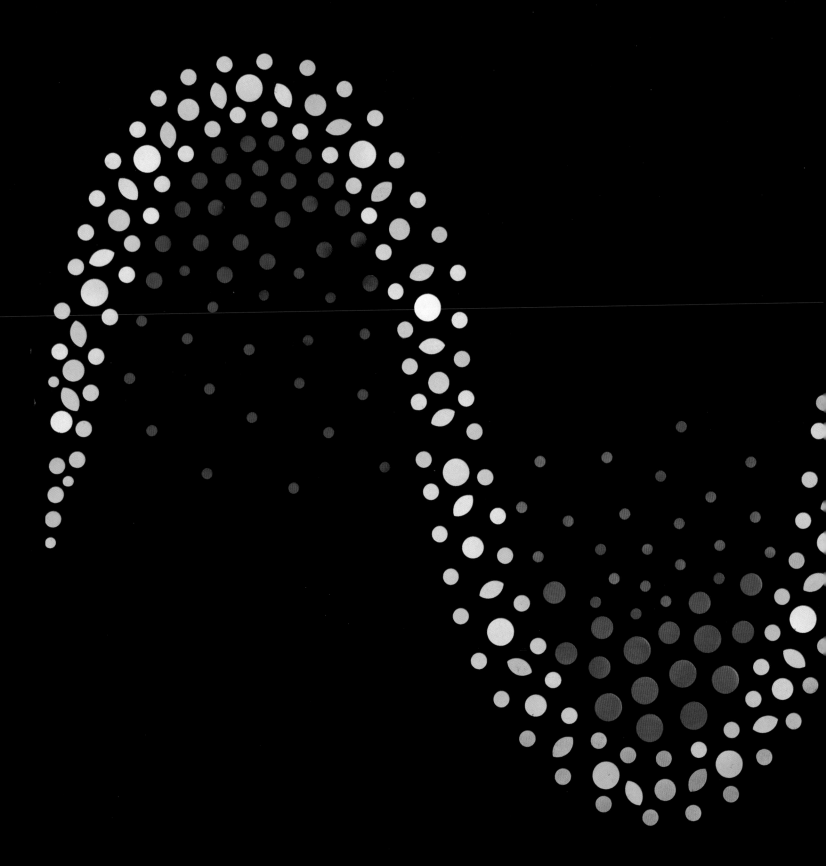

Stimulus, Pure Structural Colour
shapes on canvas (1.6 m x 3 m),
Andrew Parker, 2019.

[overleaf] Details from *Stimulus*.

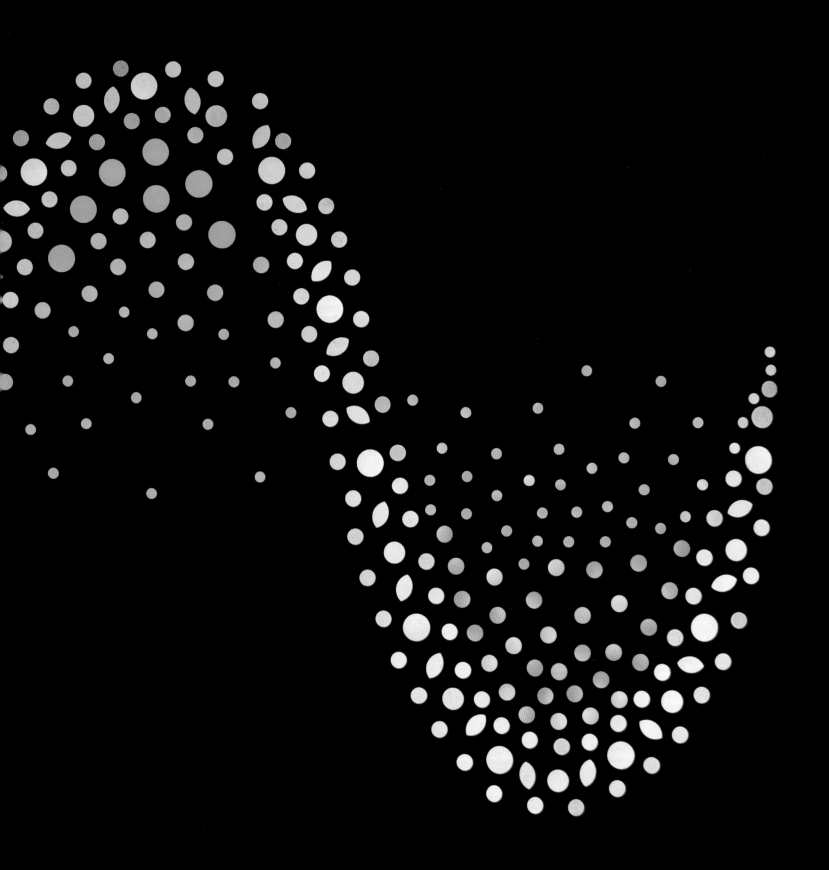

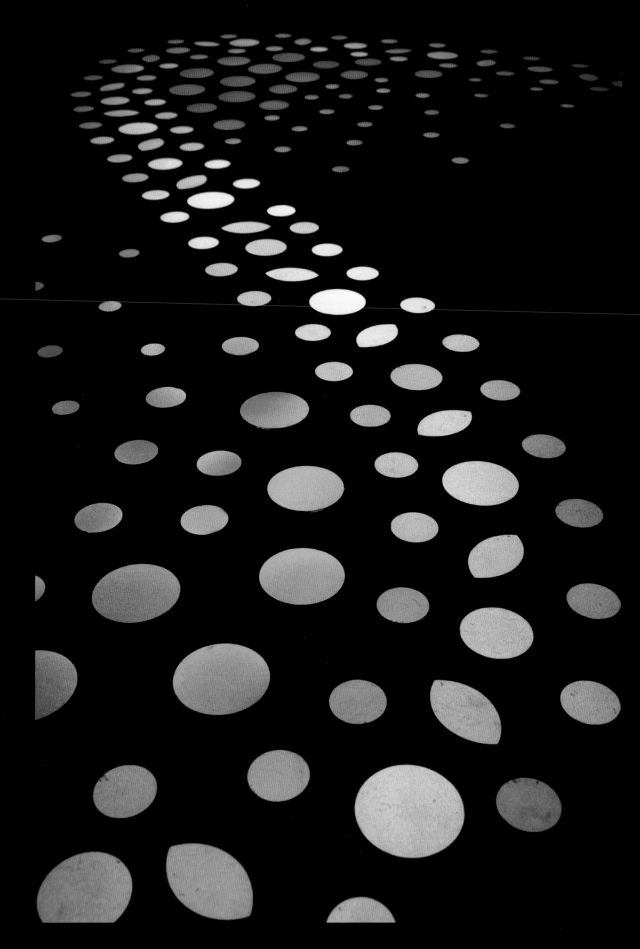

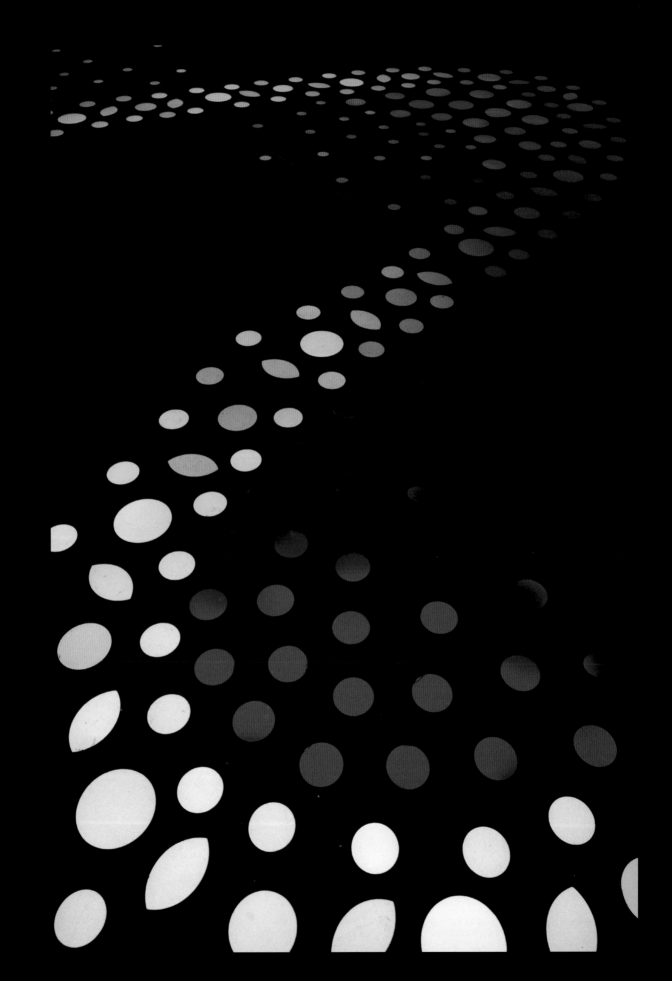

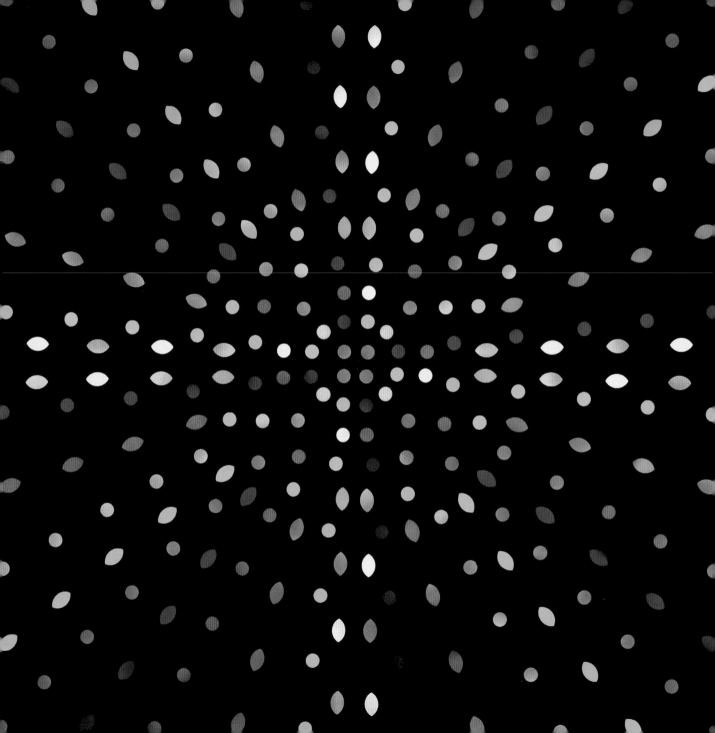

Life's Big Bang, Pure Structural Colour shapes on canvas (1.6 m x 1.6 m), Andrew Parker, 2019.

[overleaf] Details from *Life's Big Bang*.

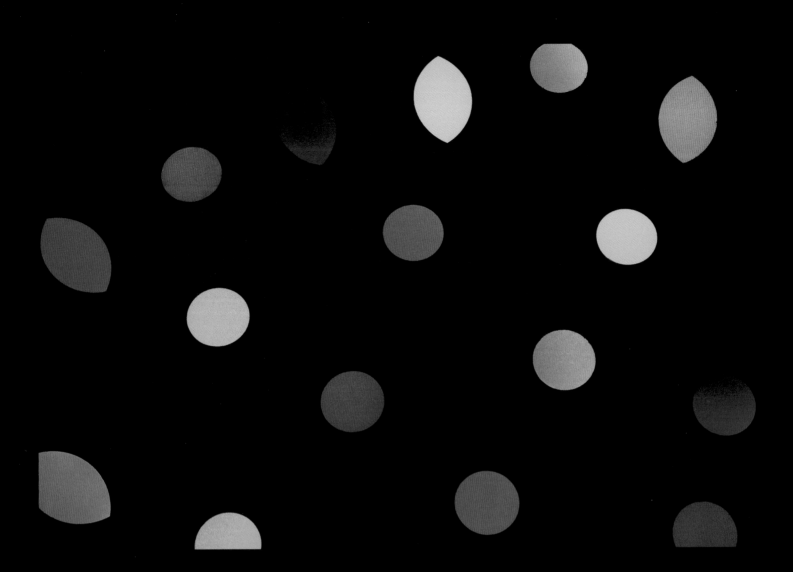

10
Optical illusions

The human visual system beholds our natural environments as 'backgrounds,' so that we are generally at ease with, and not distracted by, nature. The equivalent of Pure Structure Colour found in animals and plants, on the other hand, evolved to add distractions. Most of nature's backgrounds are coloured by pigments, so set against these, Pure Structural Colour will draw the eye.

Two-dimensional discs of Pure Structural Colour, 50 cm in diameter, in different hues, were placed in natural environments and photographed. The results were more pronounced than anticipated. Not only did the discs become the focus of attention in each scene, but their brightness elicited an optical illusion, causing them to appear as three-dimensional shapes or spheres.

The human eye did not evolve to interpret such large swaths of Pure Structural Colour set within a natural scene, and so the brain reaches for the nearest neurological pathways to decipher the unknown quantity. The discs are assigned the closest fit from the brain's lexicon, which happens to be 'sphere.'

Although more pronounced when viewing the actual Pure Structural Colour discs in person, the effect is still captured on camera. This is due to the large diameters of the discs, which offer a slight variation in hue across their surfaces, giving the brain something to think about, along with their comparative brightness.

[pages 97–105] Pure Structural Colour discs in natural settings, Shropshire, UK. Photography by Ben Osborne.

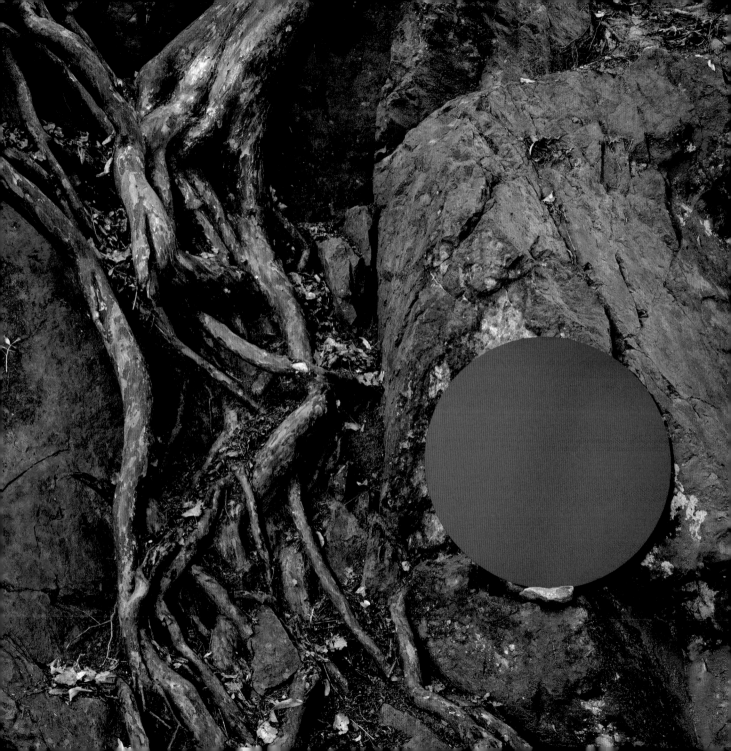

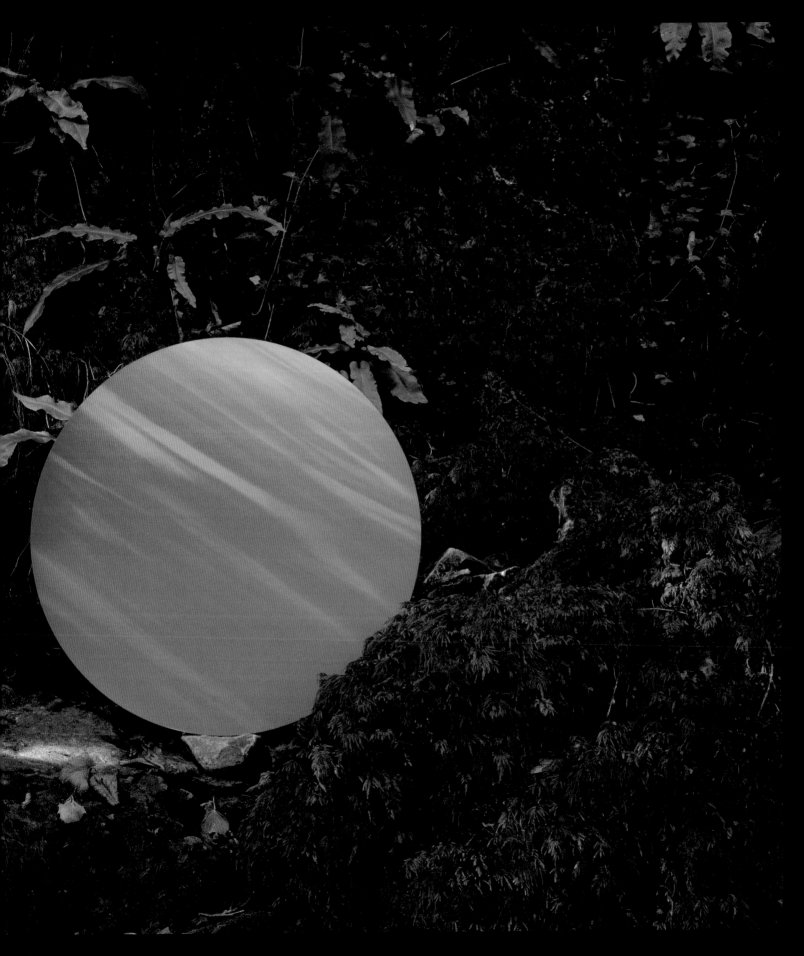

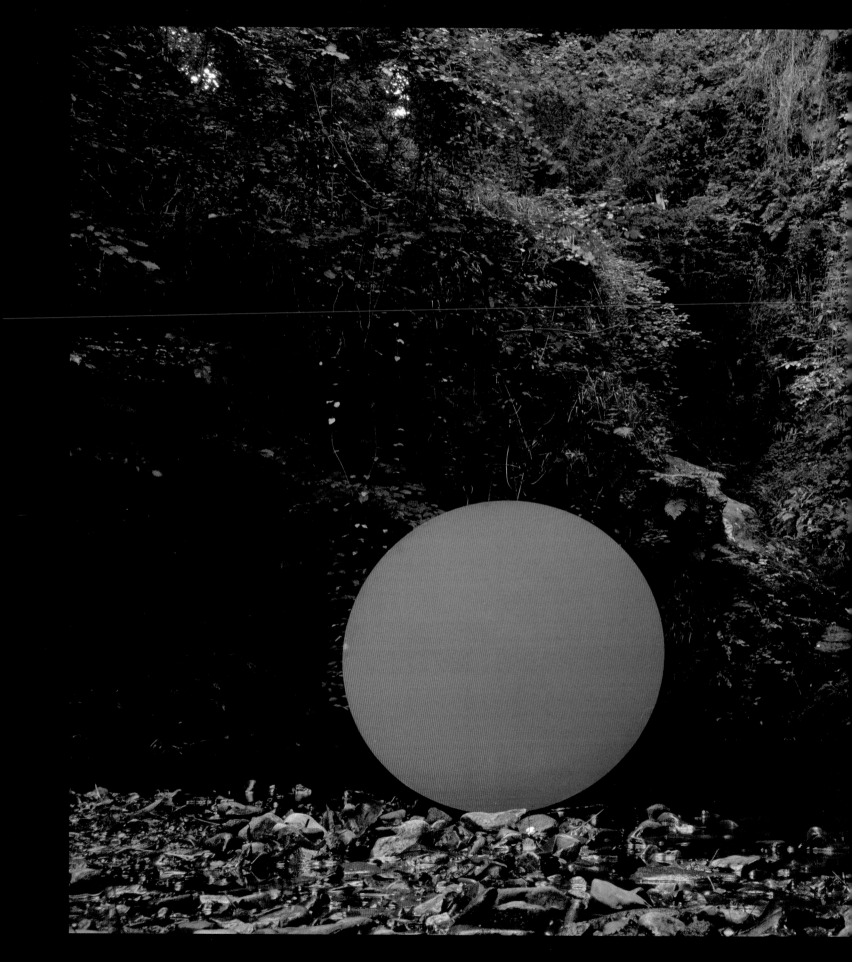

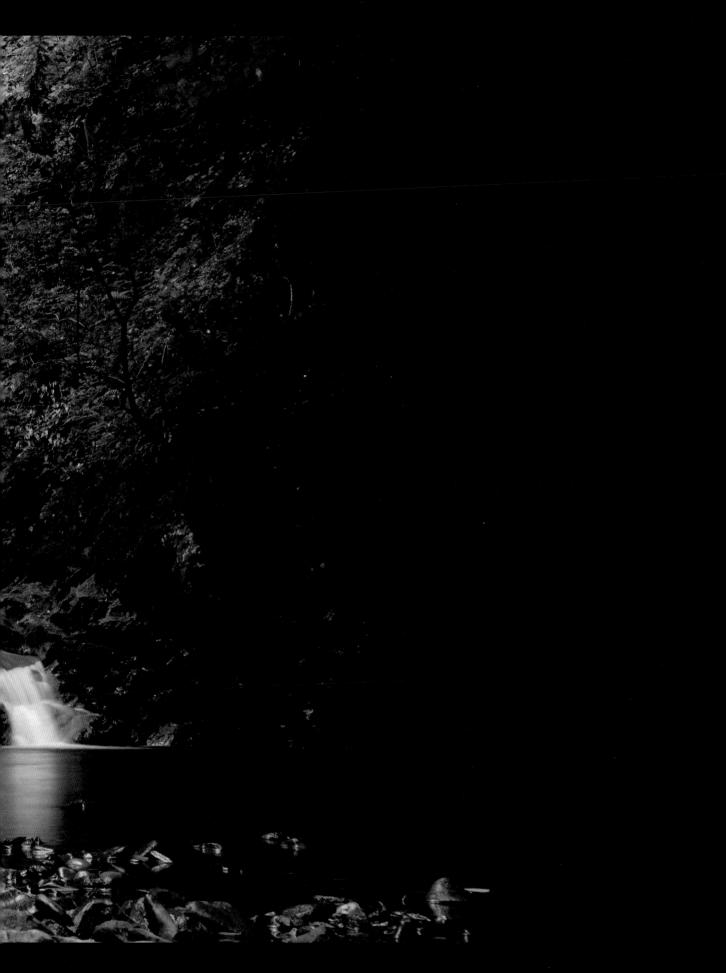

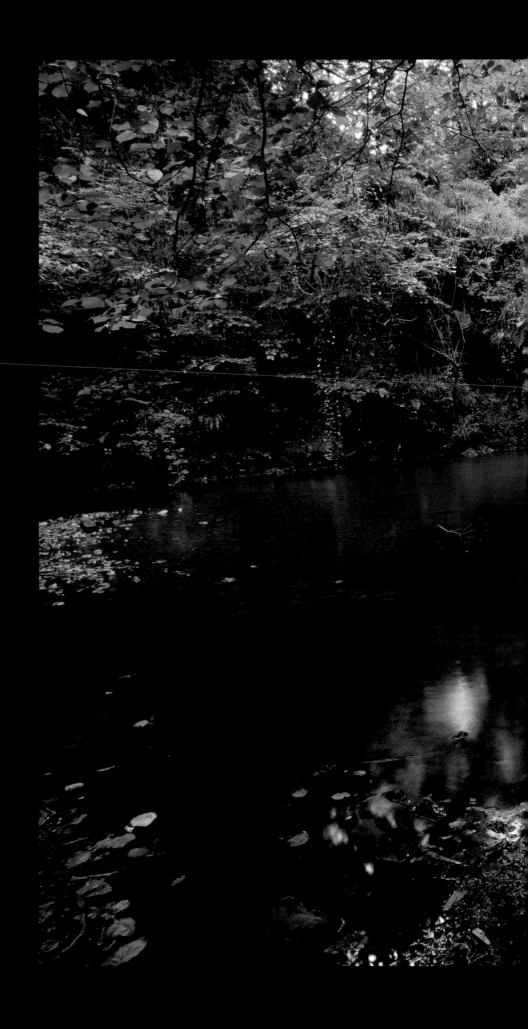

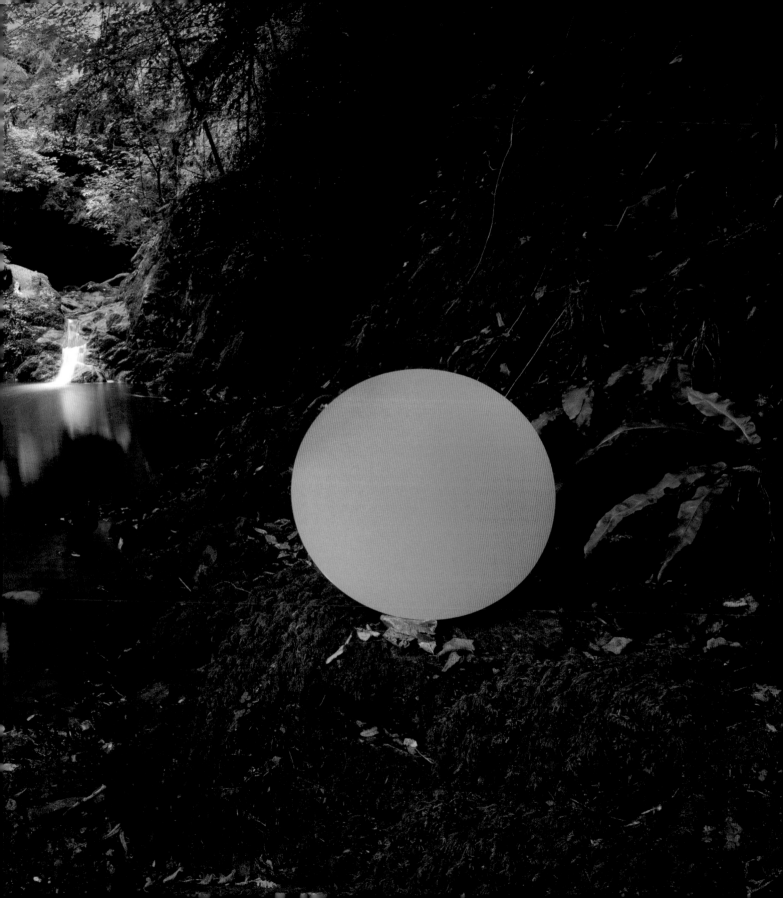

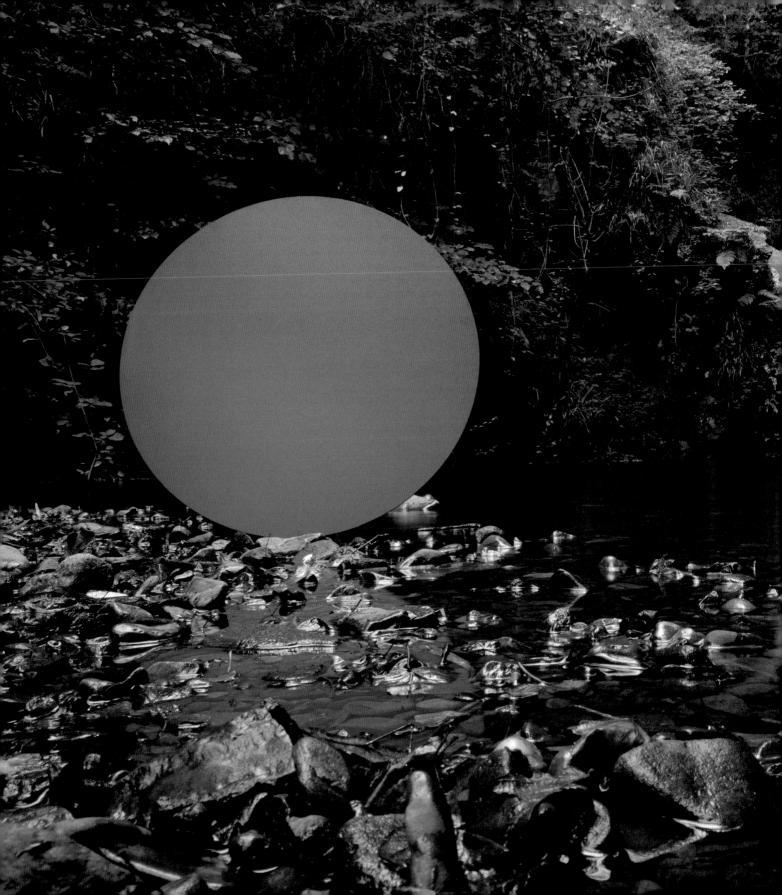

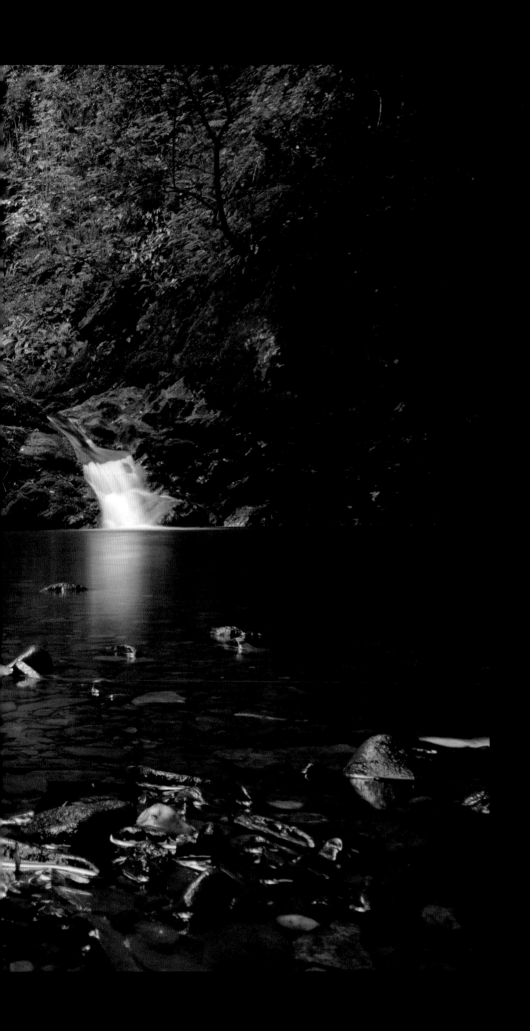

11
Bio-inspiration

Pure Structural Colour is the product of bio-inspiration, where an innovation in nature has inspired a technology fit for our own purposes. Imagine the applications of Pure Structural Colour in some of the products we possess. Pure Structural Colour is a viable alternative to pigments found in our paints and colourants, but in the case of at least some hues, it comes with a reduced environmental footprint.

If we can learn from other innovations in nature in a similar manner, and if those cases build up, we could help to save the planet through the use of more environmentally friendly products. After all, the 'technologies' of animals and plants are biodegradable and do not involve chemicals or materials that harm the environment. Also, cases of bio-inspiration have the potential to attract our interest and bring a better understanding of, and passion for, nature into the public sphere. These are the founding principles of the organisation Lifescaped (www.lifescaped.com).

In addition, in the case of colour, a bio-inspired approach may bring further implications for our well-being. We perceive and enjoy the types of colours we find in nature because of the long evolution of our ancestors. The bright colours in nature became a stimulus to boost our morale, perhaps to help early humans to get through difficult times, such as an ice age. Perhaps that's why we are so receptive to Pure Structural Colour. Maybe if we could reproduce such types of colour in our buildings and possessions, then we could improve our health and well-being.

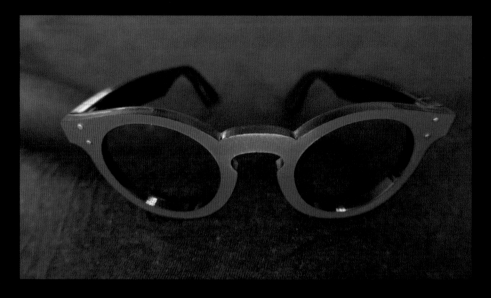

Sunglass frames using Pure Structural Colour (Lifescaped).

Pure Colour Studio

The design and production of the artworks in this book were made at Pure Colour Studio, the arts and design arm of Lifescaped. Through a collaboration with The Prince's Foundation School of Traditional Arts, we use geometry in nature to bring evolved patterns into design. These designs may appeal to our visual systems, which have themselves evolved to appreciate such patterns (as a feature of our natural backgrounds.) Hopefully this link to nature will also influence our mind-set, to favour our re-connection to natural processes.

Lifescaped

Harmony

In the bigger picture, bio-inspiration is just one of many concepts we may adopt to bring us closer to nature, and veer us away from our current path towards environmental destruction. Bio-inspiration is a feature of 'Harmony,' a model proposed by HRH The Prince of Wales, who has emphasised the need to 'create resilient, truly sustainable and human-scale urban environments that are land-efficient, use low carbon materials and do not depend so completely upon the car.' Harmony takes into account architecture and planning, agriculture, education, the arts, healthcare, society and economy, which have all suffered as a result of their disconnect from nature.

In his 2011 concept 'The Symbiocene', environmental scientist Glenn Albrecht argues that the next era in human history must be modelled on symbiosis, the natural mechanism of living together for mutual benefit. The interconnection and interaction of humans and other species and natural processes, if realised as a goal in the global mindset, would reverse our current environmental trends (that could become associated with our existing era in history, the Anthropocene). Taking design inspiration from nature would represent a step towards this goal, or could at least positively influence our mindset.

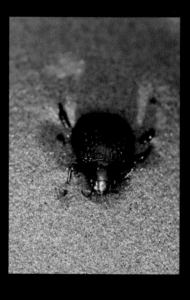

[left] A *Stenocara* beetle from the Namib desert. This beetle collects water from desert fogs in a region where rainfall is negligible. The microscopic structures on the beetle's back, which make this feat possible, have been reproduced by printing techniques and can be used to collect water for human consumption and medicine where water supplies are limited.

[right] A cone shell with a colour-fast violet pigment. Tyrian purple was extracted from molluscs, and used as a fabric dye, by the ancient Phoenicians and Romans.

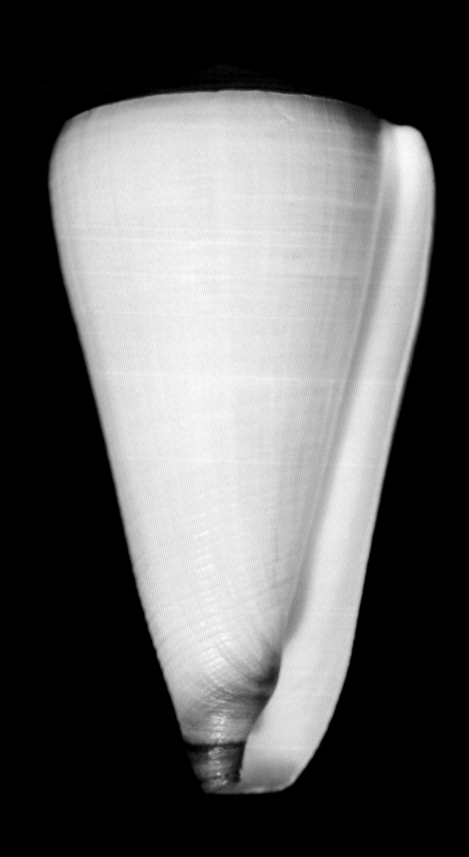

Further reading

For information on colour in nature and the impact of the evolution of vision:

Parker, Andrew. (2016). *In the Blink of an Eye*. 3rd revised edition. The Natural History Museum, London.

Parker, Andrew. (2022). *The Line of Sight*. Atlantic Books, London; W. W. Norton & Company Inc, New York.

Parker, Andrew. (2016). *Seven Deadly Colours*. 3rd revised edition. The Natural History Museum, London.

For further information on bio-inspiration:

www.lifescaped.com – More about the work of Andrew Parker and the application of bio-inspiration projects in research, education and commerce.

Dennett, Daniel C., Roy, Deb. (2015). How Digital Transparency Became a Force of Nature. *Scientific American.* March, pages 64–69. www.scientificamerican.com

Mueller, Tom. (2008). Biomimetics: Design by Nature. *National Geographic Magazine*. April, pages 68–91. www.nationalgeographic.com

Sources:

Gould, John. (1880-87). *A Monograph of the Trochilidae, or Family of Hummingbirds*. 5 volumes. Henry Southern & Co., London.
online: www.biodiversitylibrary.org

Thornton, Robert John.(2008) *The Temple of Flora*. Facsimile edition of original published in 1807 by T. Bensley, London. Taschen, Köln.
original online: www.biodiversitylibrary.org

Acknowledgements

Thanks are due to the following people for their help throughout the many years of the Pure Structural Colour project:

Dr Irene Votta and Dr George Richardson, Lifescaped, for help with the manufacture of Pure Structural Colour flakes used in Coral G. Guest's painting *Pollia*.

Coral G. Guest for her patience and persistence in taking on the challenge of producing the first painting containing Pure Structural Colour flakes.

Dr Hua-Kang Yuan, Lifescaped for the optical modelling of Pure Structural Colour.

Dr Tegwen Malik, Lifescaped, Takashi Tokuda, Keigan Inc. (Japan), and Enzo Fiondella, Interactive Imagination, for their help with the manufacture of the kaleidoscope apparatus.

Nick Morris and Bea Addis, Lifescaped, and Al Lukies CBE, for their work on commercial applications for Pure Structural Colour.

Jean-Luc Ambridge (Makerversity) for laser cutting individual pieces for artworks.

Ben Osborne for his photographic work.

Jim Sutherland for his long-time input on design, the use of geometry in nature and rendering of Pure Structural Colour.

Marc Newson and Nic Register for their lessons on design and commercial applications.

Jan Casey for her long term management of the design aspects of this project.

Les Parker, Irene Parker and Natalia Martini for help with the building of artworks.

Dr Shirley Sherwood OBE for advice on botanical art.

Maria Devaney, Gina Koutsika and Paul Denton for help with exhibition/artwork management and curation.

The Kew Publishing team: Lydia White for project managing, Ocky Murray for the design, Michelle Payne and Gina Fullerlove for their editorial work, and Georgie Hills for print production.

Index

Image references in **bold**

Picture credits

Photographs of artworks and natural subjects were all taken by Ben Osborne, except for the following, which were taken by Andrew Parker: Chapter 1 – all; Chapter 2 – all; Chapter 3 – prism, cassowary, flamingo, red flower, *Acacia*, lily, ostracod, *Begonia*, *Selaginella*; Chapter 6 – colour swatches; Chapter 7 – all; Chapter 9 – *Eye Geometry, Inverse Eye Geometry*; Chapter 11 – sunglasses, *Stenocara*; Chapter 12 – cone shell.

A further exception is that Coral G. Guest took the photograph of her painting, *Pollia*, in Chapter 6.

Ben Osborne took the photographs used on the cover.

The artworks *Eye Geometry* and *Seven Discs* were made through a collaboration of artists and ideas.

The remaining Pure Structural Colour artworks were made by Andrew Parker.

© The Board of Trustees of the Royal Botanic Gardens, Kew 2021

Text © Andrew Parker
Images © Andrew Parker unless otherwise stated (see picture credits above)

First published in 2021
Royal Botanic Gardens, Kew,
Richmond, Surrey, TW9 3AB, UK
www.kew.org

ISBN 978 1 84246 733 6

Distributed on behalf of the Royal Botanic Gardens, Kew in North America by the University of Chicago Press, 1427 East 60th St, Chicago, IL 60637, USA.

British Library Cataloguing in Publication Data
A catalogue record for this book is available from the British Library

Design and page layout: Ocky Murray
Project management: Lydia White
Production management: Georgie Hills, Jo Pillai
Copy-editing: Michelle Payne
Proofreading: Gina Fullerlove

Printed and bound in Italy by Printer Trento srl.

For information or to purchase all Kew titles please visit shop.kew.org/kewbooksonline or email publishing@kew.org

Kew's mission is to be the global resource in plant and fungal knowledge and the world's leading botanic garden.

Kew receives approximately one third of its funding from Government through the Department for Environment, Food and Rural Affairs (Defra). All other funding needed to support Kew's vital work comes from members, foundations, donors and commercial activities, including book sales.

Front cover: *Life's Big Bang*, Pure Structural Colour shapes on canvas (1.6 m x 1.6 m), Andrew Parker, 2019.

Inside front and back cover: Pure Structural Colour discs in natural settings, Shropshire, UK. Photography by Ben Osborne.

Inside back cover: *Stimulus* (detail), Pure Structural Colour shapes on canvas (1.6 m x 3 m), Andrew Parker, 2019.

Page 2: Blurred hummingbirds, Lifescaped's hummingbird cabinet, photograph by Ben Osborne 2019.

Page 4: *A Community of Colour Under Sunlight*, acrylic on canvas, Andrew Parker 2019.

Page 6: *Biological Form*, watercolour on paper, Andrew Parker 2020.

Page 8: *Converting the World to Colour* (detail), acrylic on canvas, Andrew Parker 2019.

FSC MIX Paper from responsible sources FSC® C015829